A DIFFERENT
DUBLIN

A DIFFERENT DUBLIN

THE 1960s THROUGH THE LENS

Photographs & text by

BILL HOGAN

CURRACH BOOKS

First published in 2019 by

 CURRACHBOOKS

23 Merrion Square
Dublin 2, Ireland
www.currachbooks.com

ISBN: 978-1-78218-906-0

Set in Adobe Garamond Pro and Lato
Cover and book design by Alba Esteban | Currach Books

Front cover image 'The man reading seemed to be engrossed in his newspaper and completely oblivious of
the younger generation. College Green.' and back cover image
'Looking for something that had fallen down the drain. Parnell Street.' by Bill Hogan

Printed by L&C Printing Group, Poland

For my wife Veronica, and my son Philip.

ABOUT THE AUTHOR

From the ages of 15-24 years, Bill Hogan worked as a projectionist in cinemas across Dublin. During this time, he became particularly interested in photography and was inspired by French photographer, Henri Cartier Bresson. His particular talent was in observing people going about their ordinary lives. As he worked mostly at night in the cinema, Hogan was able to spend his time wandering the streets of Dublin during the day with his camera. This collection of candid shots of city life in Dublin in 1960s is the result.

INTRODUCTION

A camera borrowed from my older brother in 1962 when I was only sixteen sparked my interest in photography, which has endured to this day. My first photograph captured the smiling faces of two ten-year-old girls viewed through a large split in a tree growing at a forty-five degree angle. I knew instinctively that what I was seeing in the viewfinder was the perfect picture, and I pressed the shutter. It felt such a natural thing to do, yet this was new and exciting. Up to that time the only experience I had had of photography was capturing more formal subjects, like people standing still, arms straight down by their side, frozen grins on frozen faces. And so began a love affair with the art of photography, of really seeing what had been before me all this time.

I started working as an apprentice projectionist in the Stella Cinema at the age of fifteen, and it was through both this and the borrowing of my brother's camera that I became aware of the power of photography. My interest led me to leaf through photography magazines like *Creative Camera*, where I learned all I needed to know about how to take a photograph. I was especially inspired by the work of French photographer Henri Cartier Bresson, and in particular by his term 'decisive moment', which in effect meant knowing precisely when to click the shutter. This is something I have tried to master in my many years of taking photographs.

In my youth I rarely went out without my camera, and through my observations from behind the lens, I began to notice all manner of subjects presenting themselves to me, simple everyday happenings that otherwise would have passed me by. Locals going about the business of shopping or chatting with friends, or the many children who used the streets of Dublin as their playground. There was great life in my home town, this city between the two canals.

I often met the well known tramps of the city, like Johnny Forty Coats and others whose names I never knew. There were the 'Travellers' or 'Itinerants' who begged on O'Connell Bridge and often improvised with milk in Guinness bottles to feed their babies. Many people had their photo taken and, promised to be, 'ready in seconds' by the Man on the Bridge, Arthur Shields.

My family was very much working class, but we had never known unemployment, and though my childhood home was nothing special, it was like a palace compared to what I saw in the more impoverished parts of the city. My brothers and I had a large garden to play in growing up, whereas some people I passed on the streets had little more than a metre of hard concrete to rest on. I will never forget the emptiness and loneliness on the faces of some of the homeless that I photographed.

There was a kind of village atmosphere in the Dublin Corporation flat developments where everyone knew their neighbours and looked out for each other as though they were family members. They would laugh and joke and would willingly fall into conversation with a stranger in the area. Amusing scenes often presented themselves to me and I felt drawn to photograph these whenever I could.

After a few years of working at the cinema and photographing, I met my wife Veronica and the hurly burly of family life took

over. My photographic pursuits became less and less frequent and my collection of negatives was largely forgotten, spending the best part of fifty years in the attic.

Around 2014, I met a young German student of photography and, upon falling into conversation about my previous photographic pursuits, she made the suggestion that the National Photographic Archive might be interested in my long-forgotten negatives. An email to the archive led to a meeting with the Archivist, Elizabeth Kirwan. She was quite taken with the images and expressed the view that they ought to be in a book. She was only the second person to ever see my collection, but gave me the confidence to pursue publishing a collection of my favourite photographs from that period of my youth.

And so now here I am, finally doing something with a bit of my past. This collection of photographs taken in the late 1960s on the streets of Dublin is the result of my efforts to represent something of what I felt and saw of fellow citizens. The daily life of city people, from the homeless to the flat dweller, were what attracted me. This was the soul of the city.

As you browse through and reflect on these images, perhaps you will feel something of what I felt. Will you feel the pain of loneliness emanating from the man sitting on a bench outside St. Stephen's Green, the emptiness in his eyes, his worldly goods wrapped up beside him? Will you smile a little at the photographs of children laughing while steeplechasing over little walls? Will the concerted efforts of family members as they attempt to change a car wheel raise a smile, or a memory?

If you remember the Dublin of late 1960's it will not be difficult for you to compare then with now. But for those who were not living at that time, these photographs can open your eyes to how life was then and how very different it is now.

It was the way we were. And the way we were makes us what we are today.

Bill Hogan

PHOTOGRAPHS

Selling artificial flowers on Henry Street.

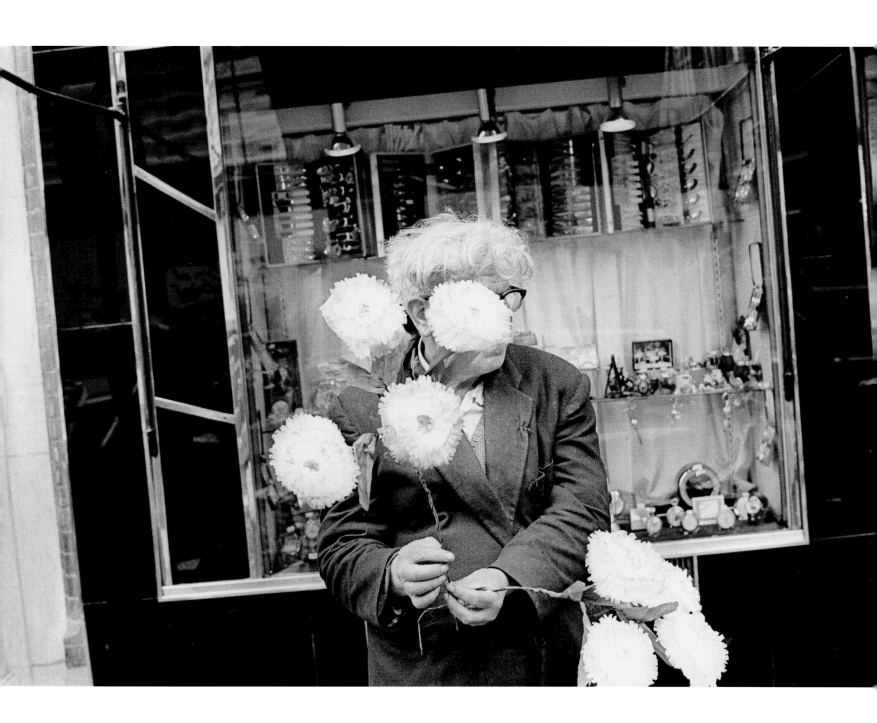

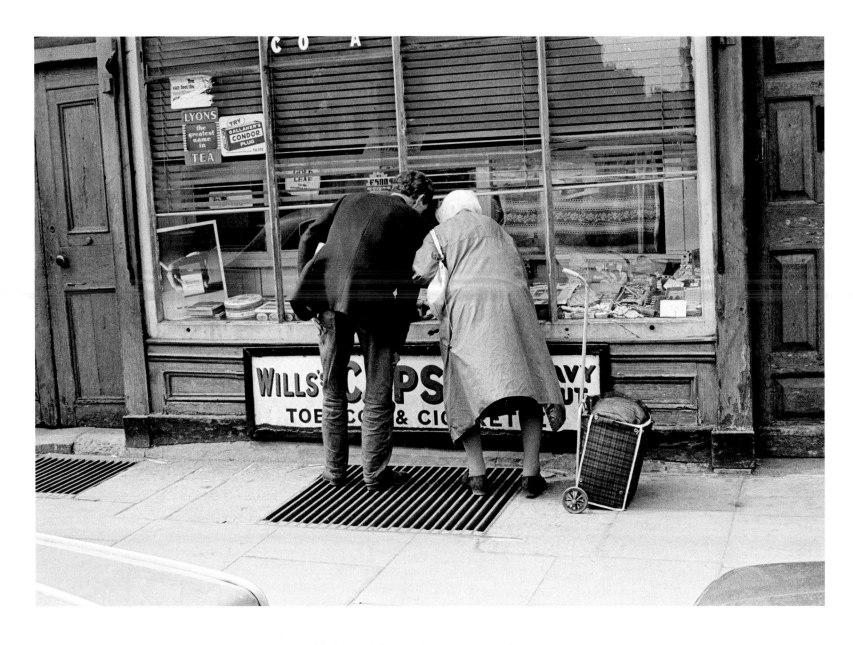

Elderly couple bargain hunting on Parnell Street.

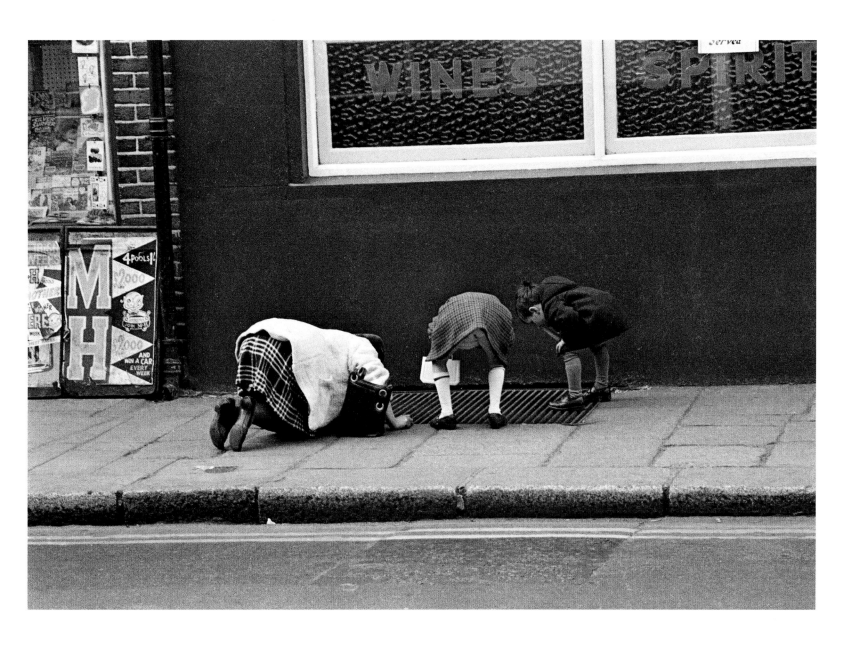

Looking for something that had fallen down the drain. Parnell Street.

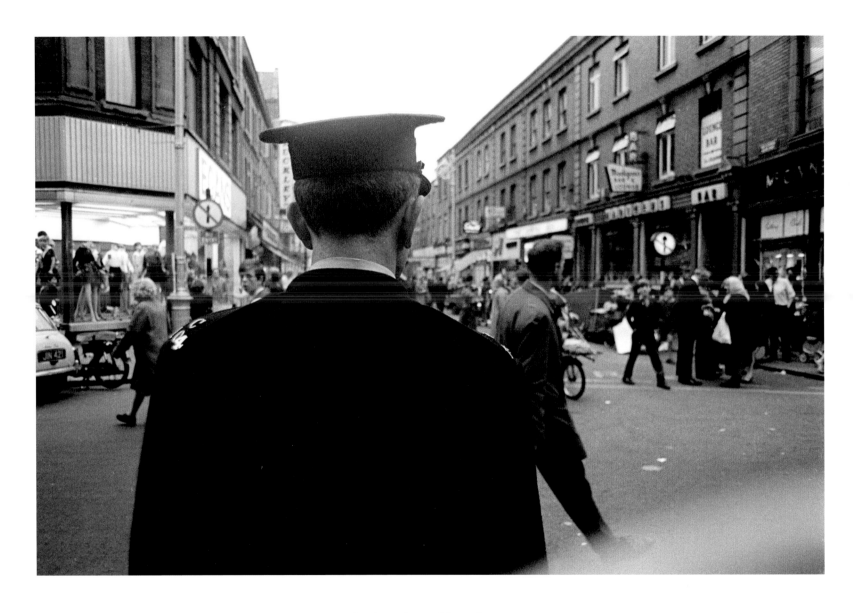

Garda on duty at Moore Street.

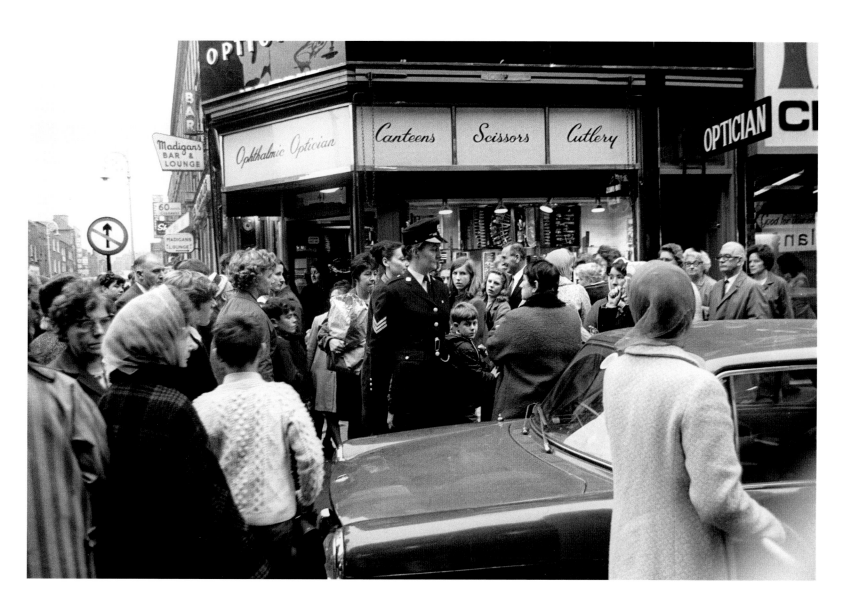

A Garda meeting opposition on Henry Street.

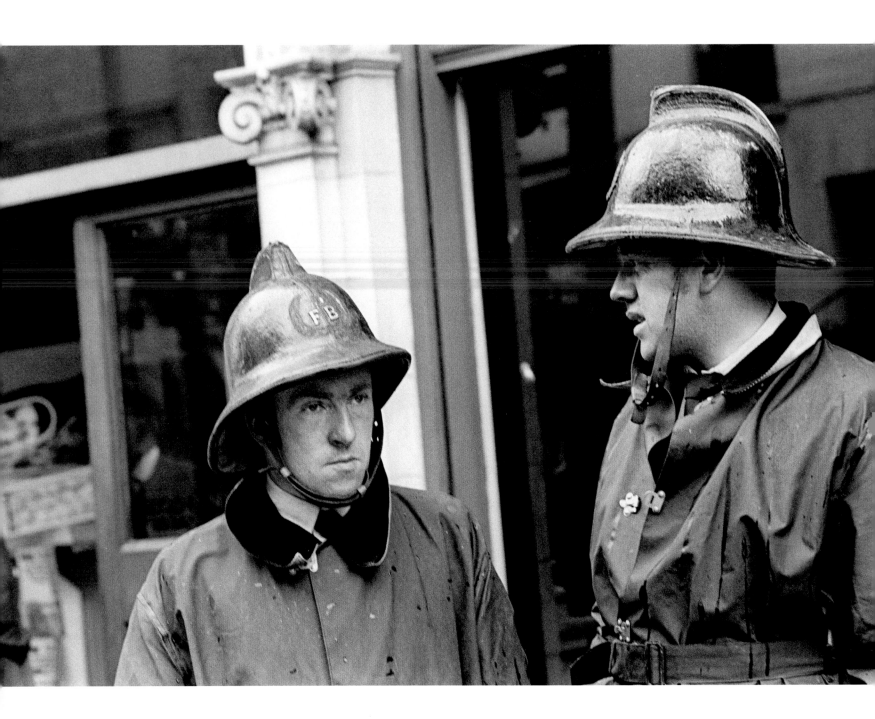

LEFT: After the fire in William's Lane, off Middle Abbey Street.

RIGHT: On guard in Middle Abbey Street at entrance to Williams Lane.

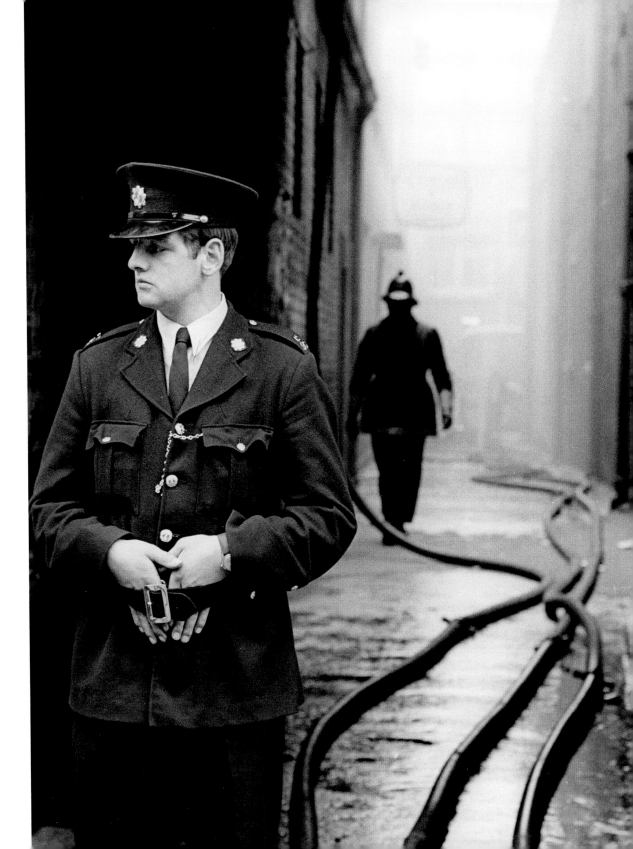

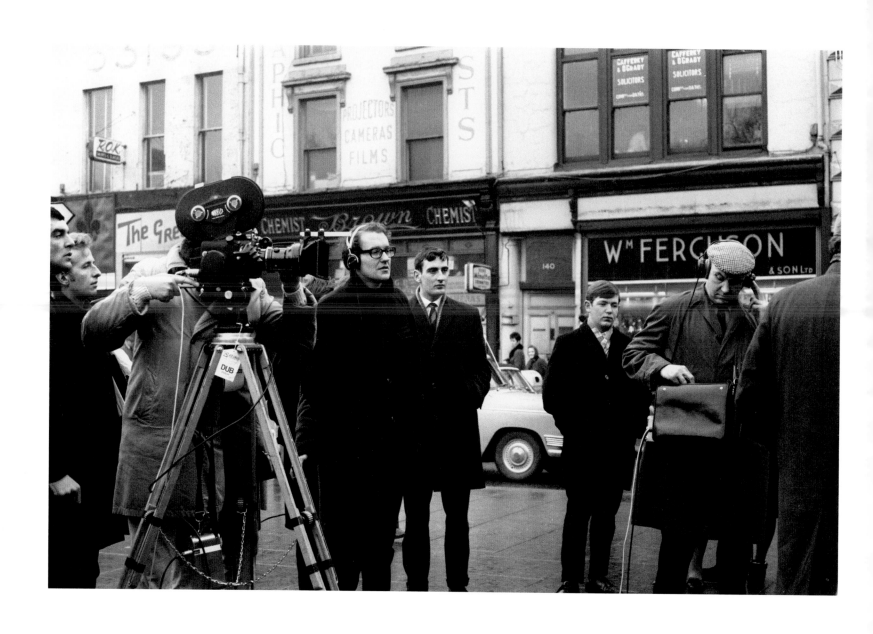

TOP: Filming on St. Stephen's Green.

RIGHT: New York Dry cleaners in Middle Abbey Street.

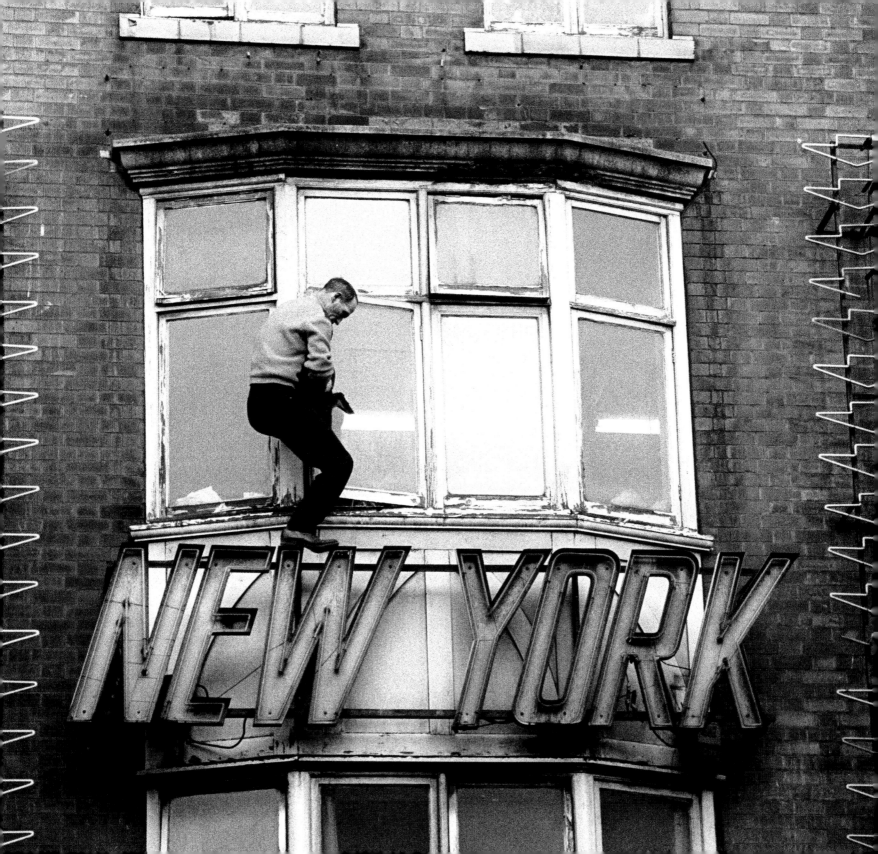

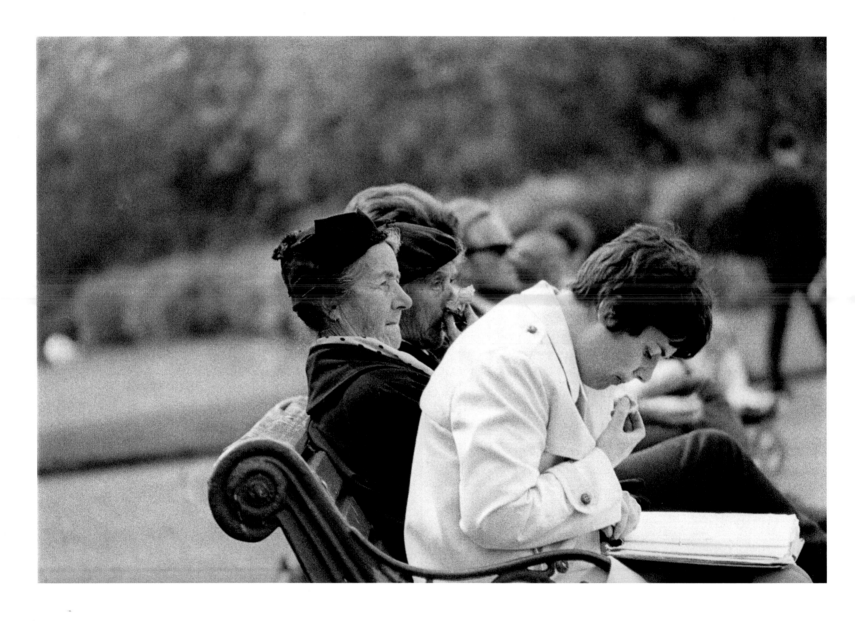

St. Stephen's Green.

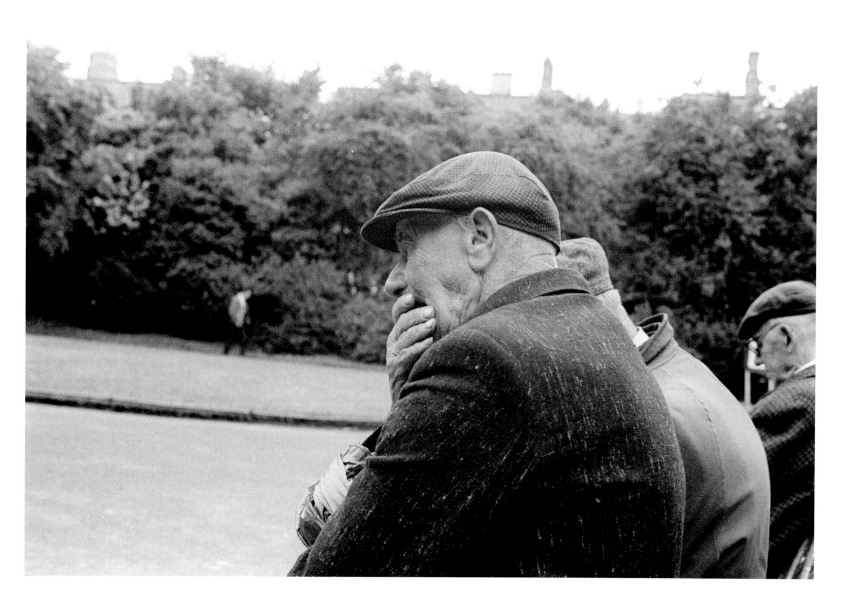

Old friends sit on a park bench. St. Stephen's Green.

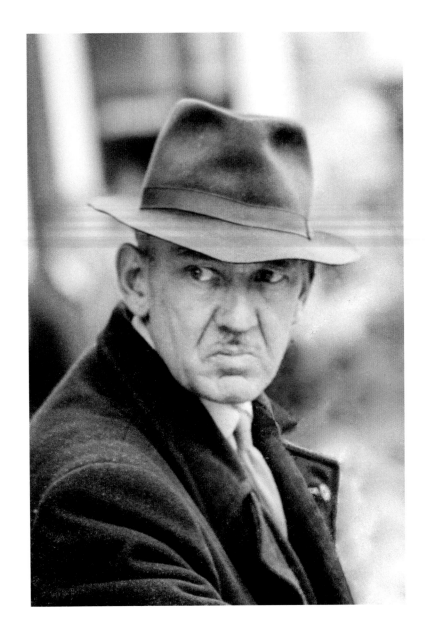

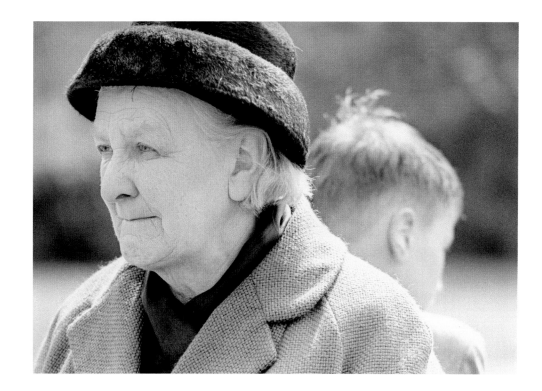

OPPOSITE LEFT: A man wearing a hat looks curiously over his shoulder. St. Stephen's Green.

OPPOSITE RIGHT: Woman making her way on North Earl Street.

TOP RIGHT: A woman and boy sitting back to back in St. Stephen's Green.

BOTTOM RIGHT: A man waiting to cross Westmoreland Street.

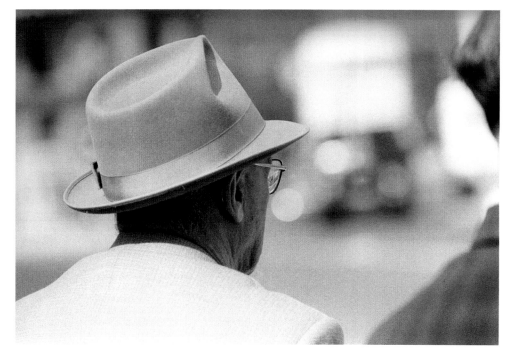

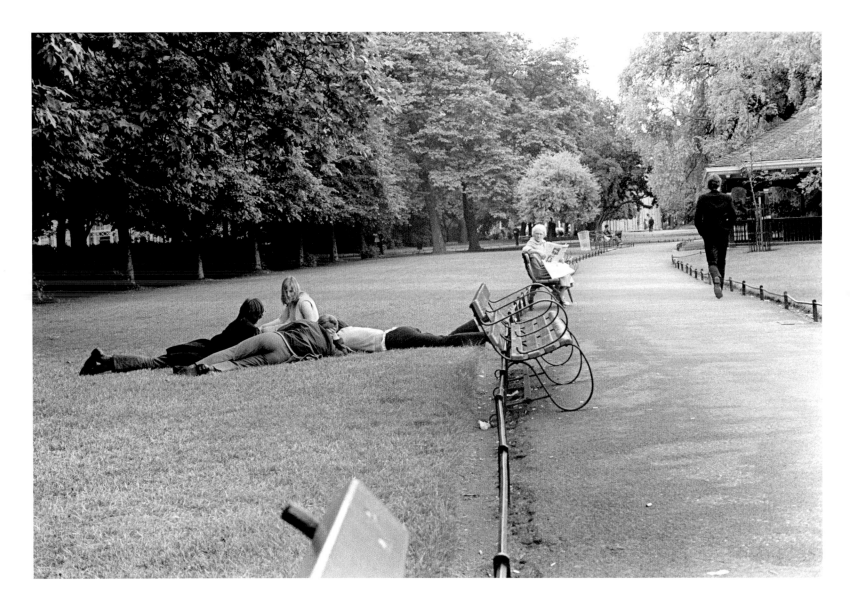

Disapproving glance, St. Stephen's Green.

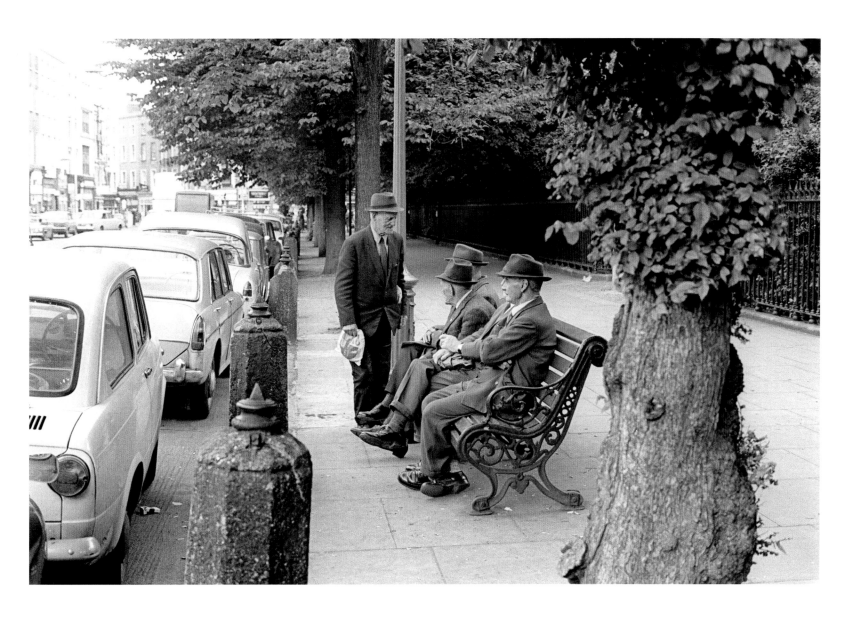

Old friends meet for a chat on bench outside St. Stephen's Green.

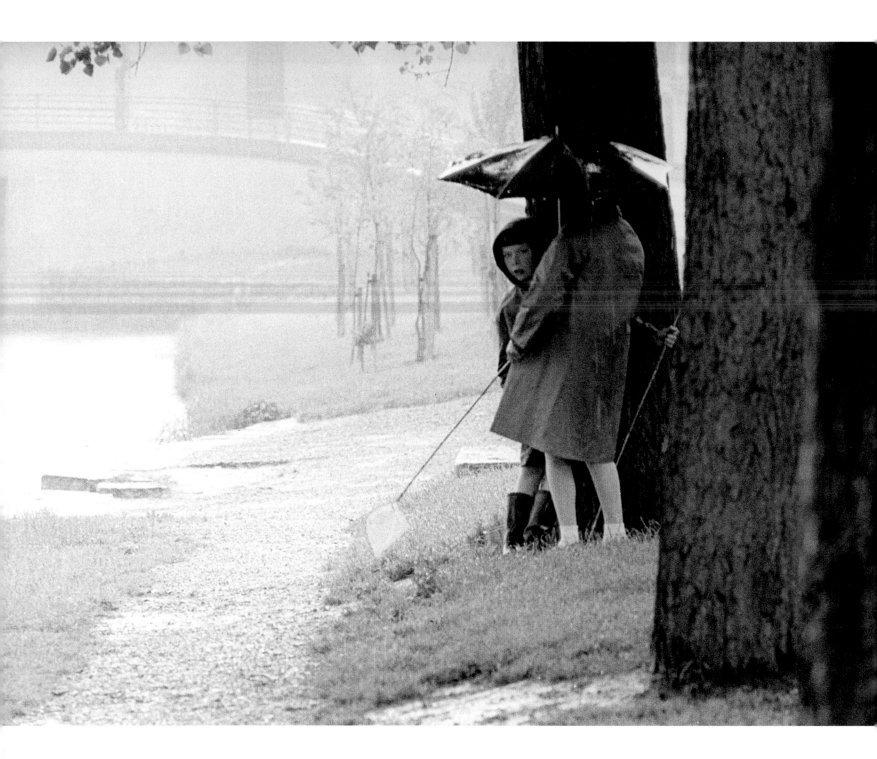

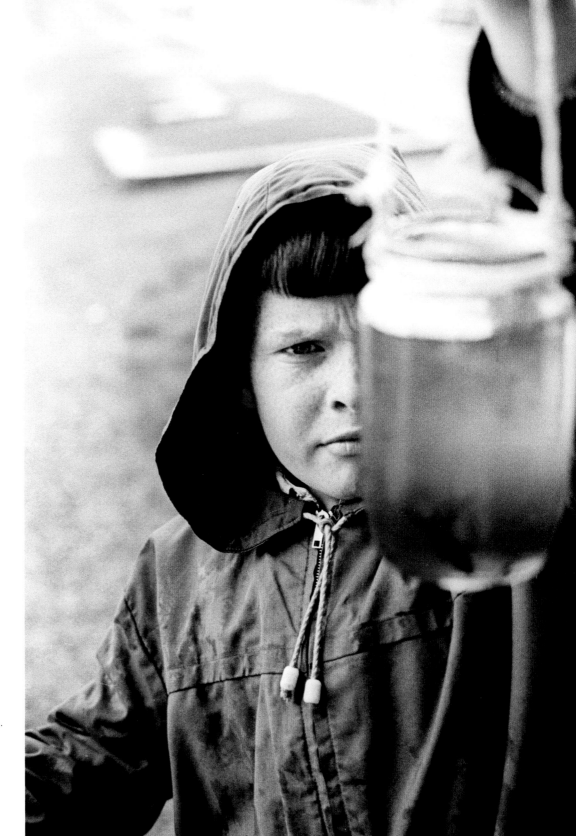

LEFT: Fishing, down by the Dodder river, Milltown.

RIGHT: Fisherman's catch at the Dodder River.

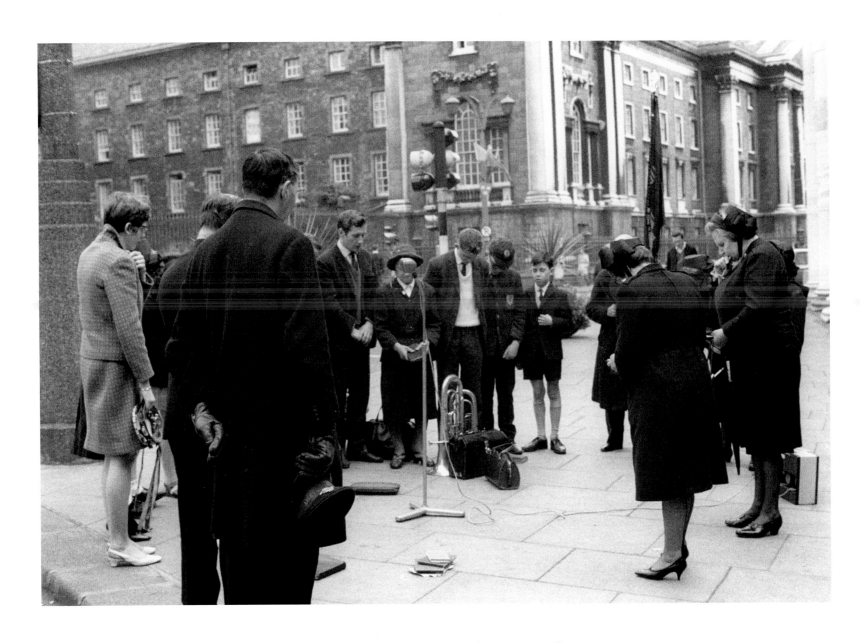

Salvation Army prayer session across from Trinity College.

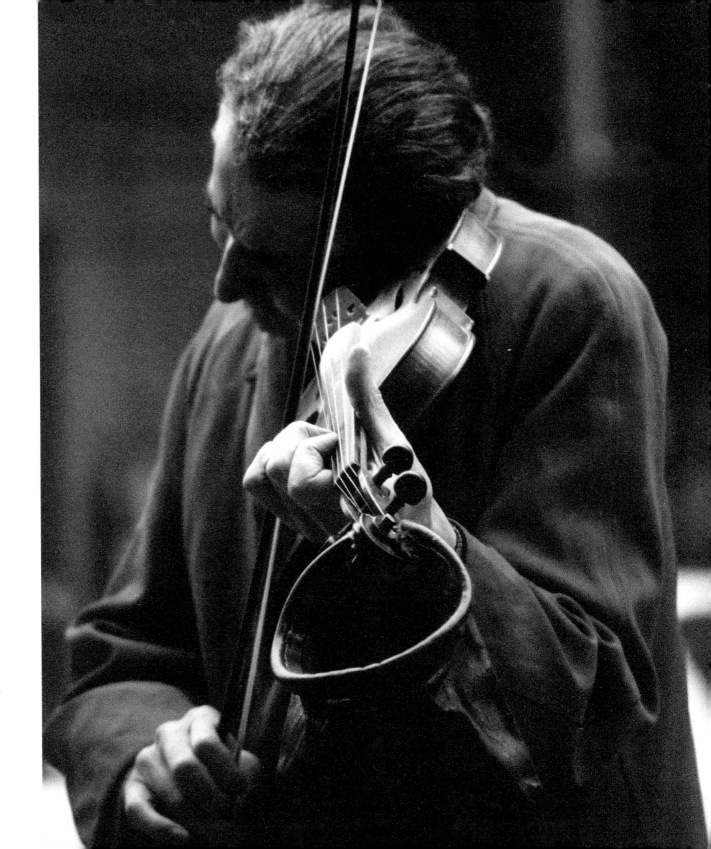

Playing the fiddle for a few
coppers in Gardiner Street.

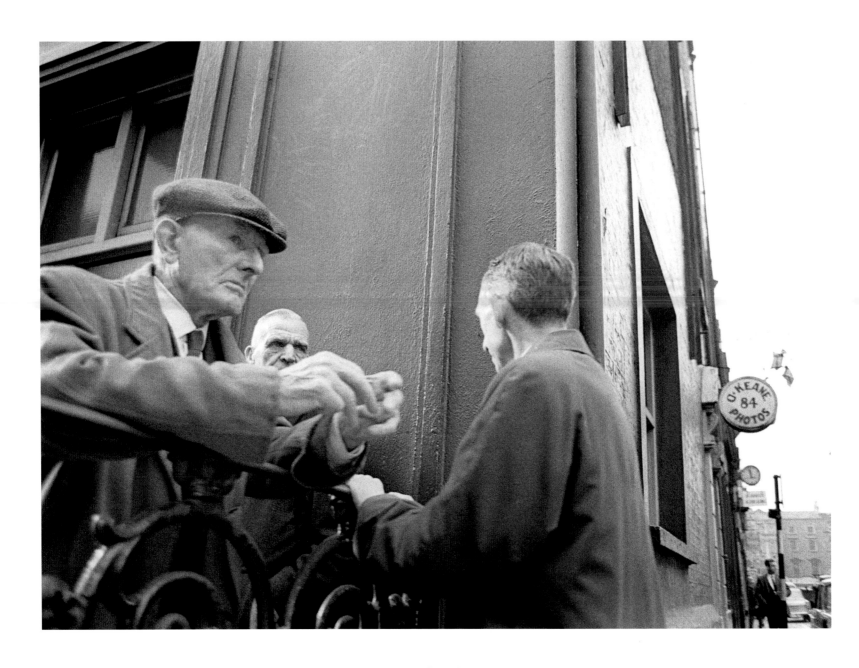

Time for a chat.

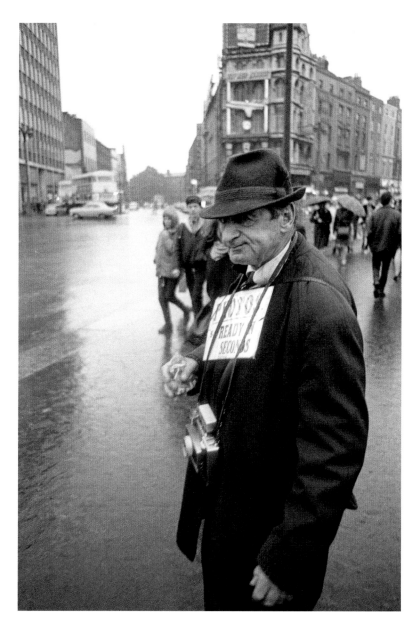

Arthur Shiels, known as 'The Man On The Bridge',
photographed people on O'Connell Bridge for years.

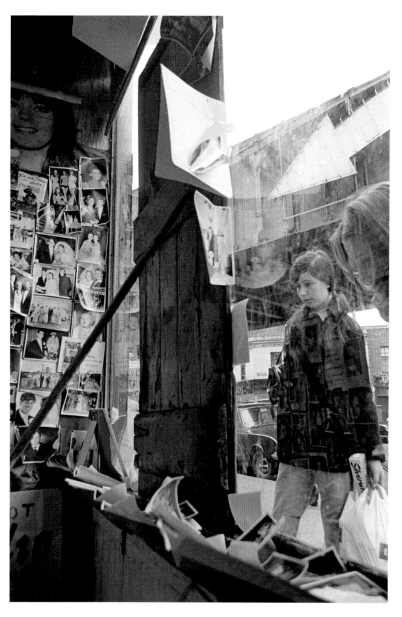

Photographer's shop window in Talbot Street.

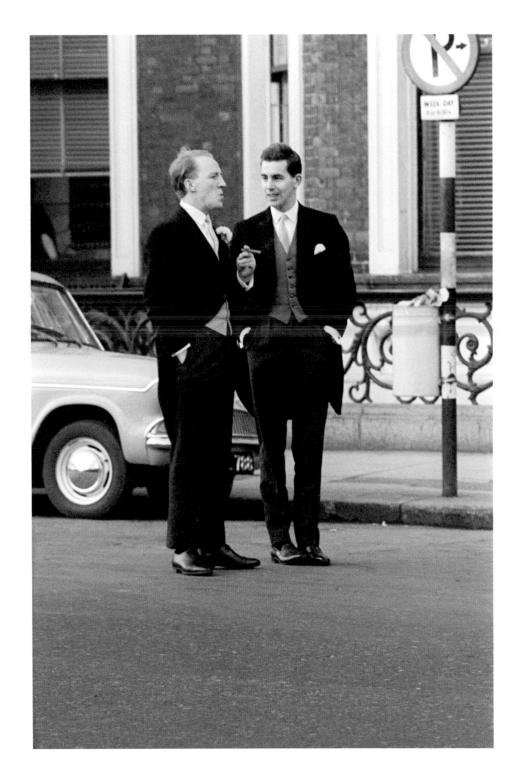

LEFT: Taking a break from the wedding. Shelbourne Hotel, St. Stephen's Green.

RIGHT: Going away cars were often daubed with wisecracks. This was no exception. St. Stephen's Green.

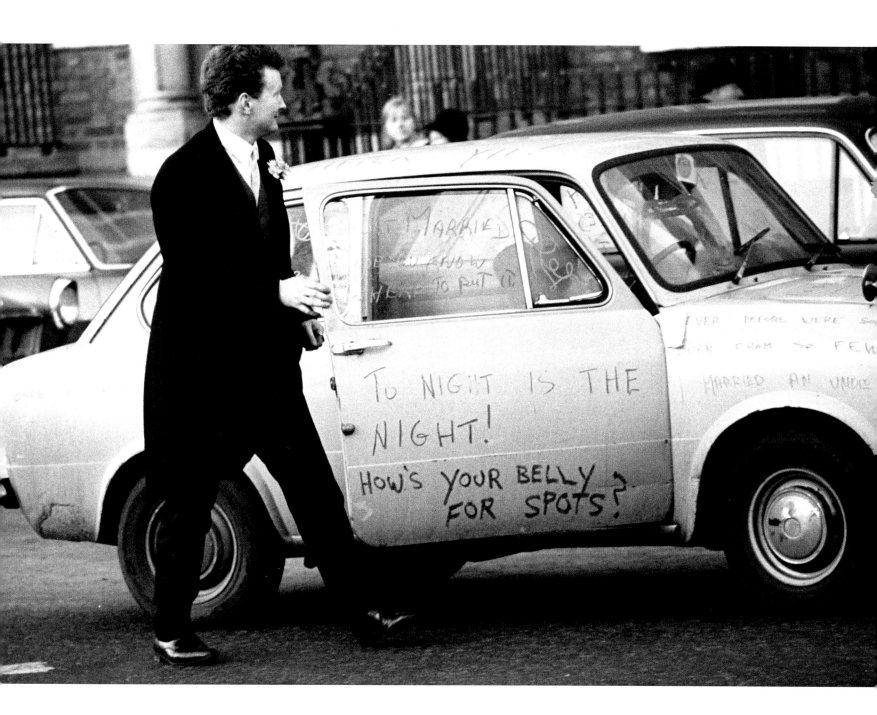

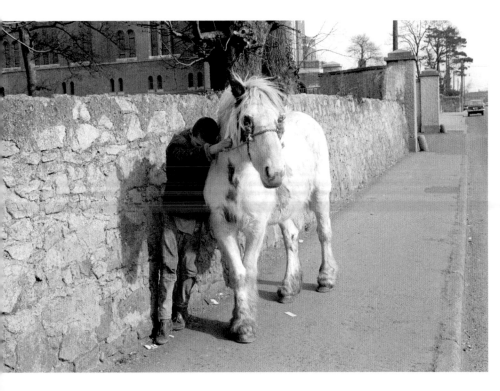

Boy attempting to mount a pony. Bird Avenue, Clonskeagh.

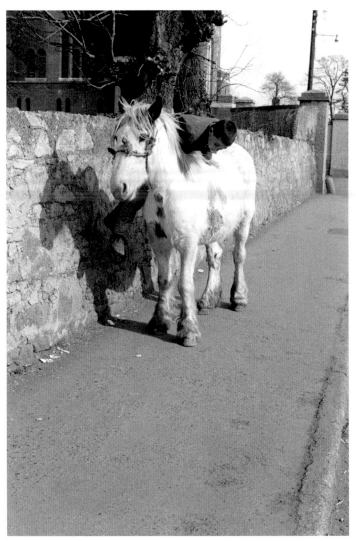

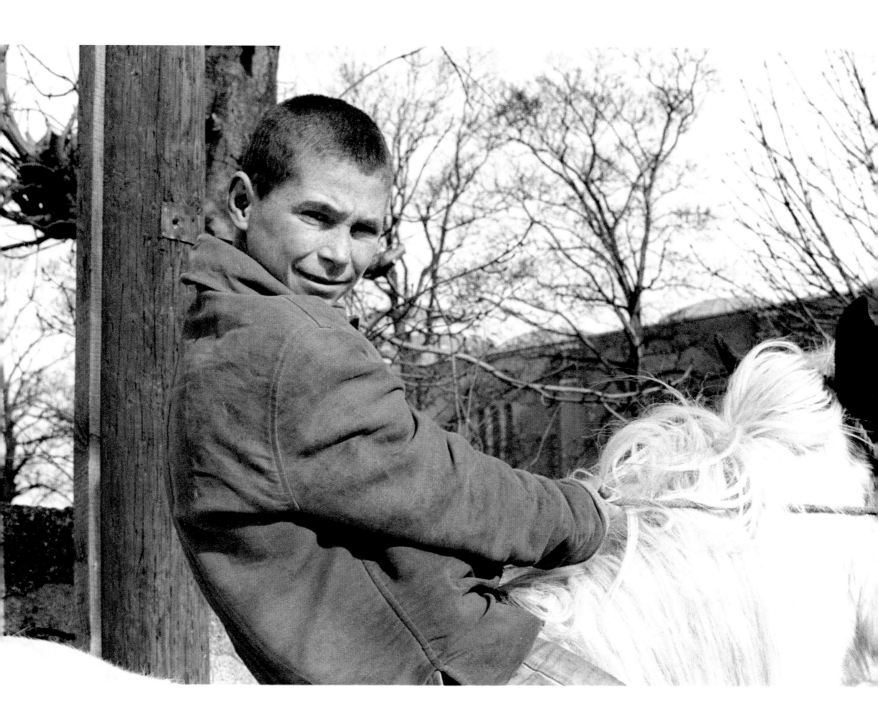

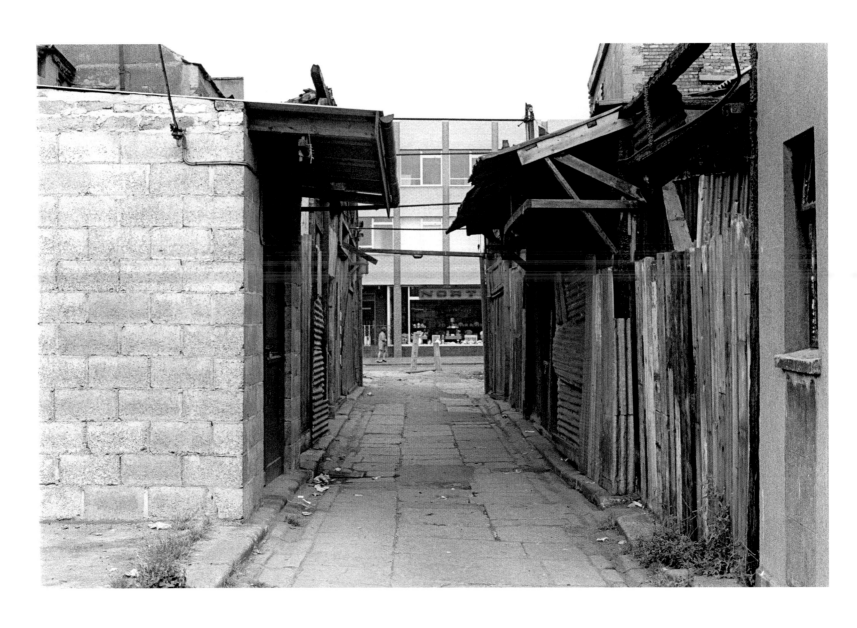

Laneway off Moore Street.

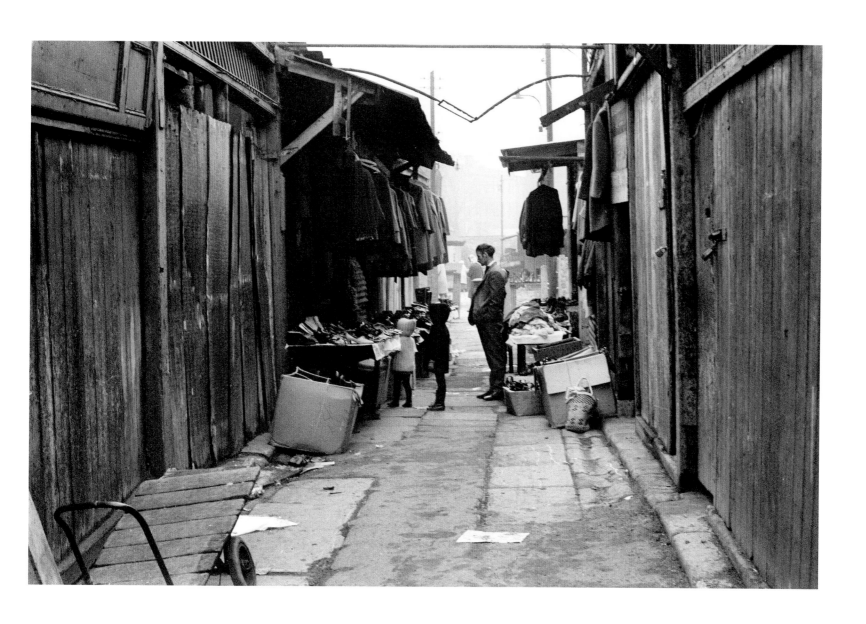

Second hand clothes in laneway off Moore Street.

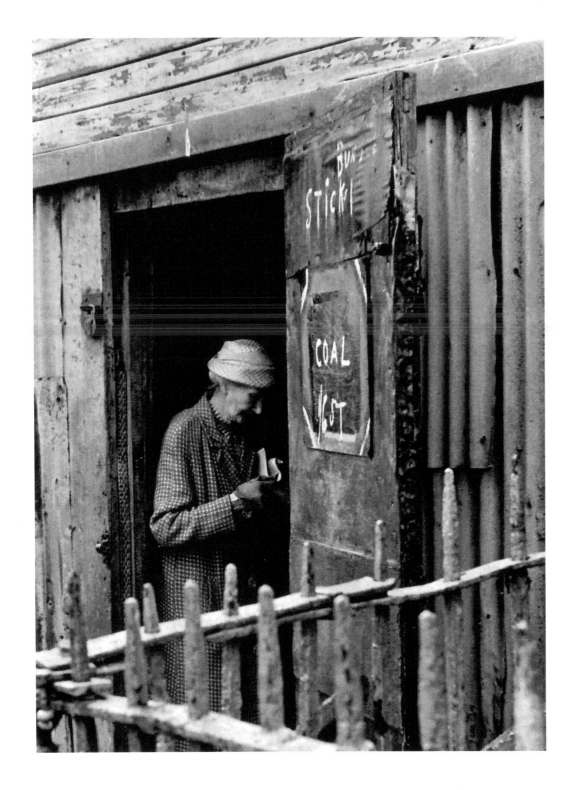

Railway Street, off Gardiner Street Lower.

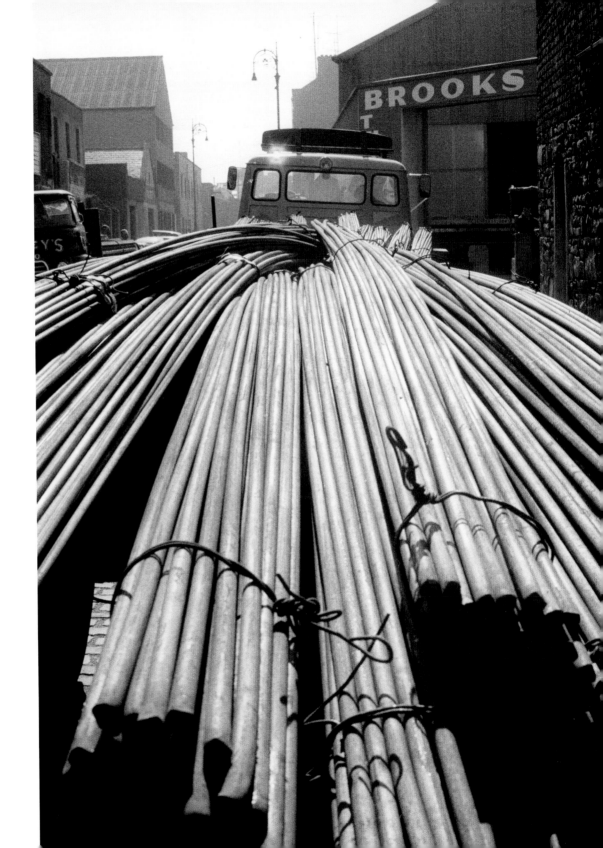

Brooks Iron Works, Foley Street.

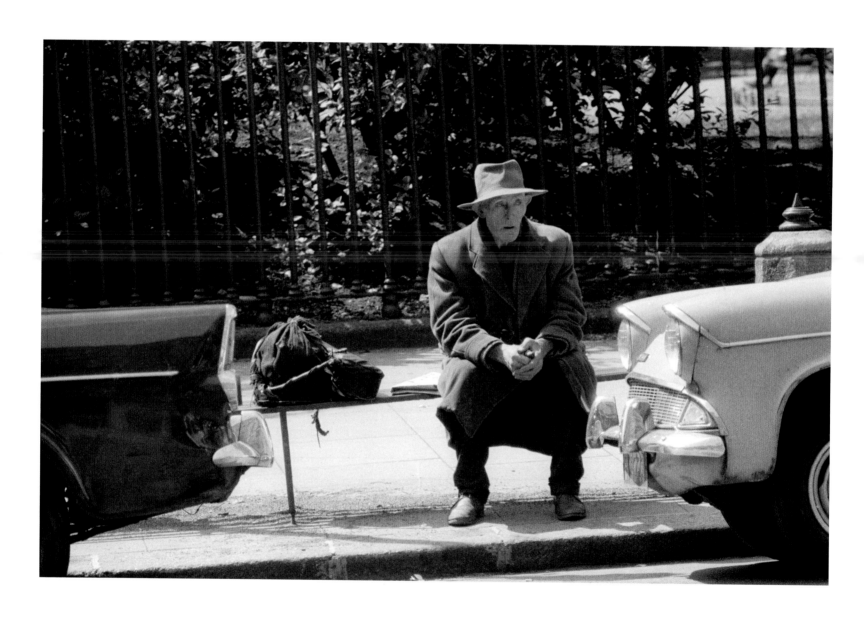

Homeless man sitting outside St. Stephen's Green.

Somehow, some times,
home ends up carried on your shoulder
and friends are benches and sunshine.

What remains of this life is but…
A bundle of memories,
Gathered since the first day.
Day when was made both
exit and entrance,
From 'there' to 'here'.

Memories unremembered,
Tangled within.
Secrets unspoken,
Stories untold.

Waiting in inner recesses,
Like Butterflies,
To fly the bars of the mind.

Alyson McEvoy

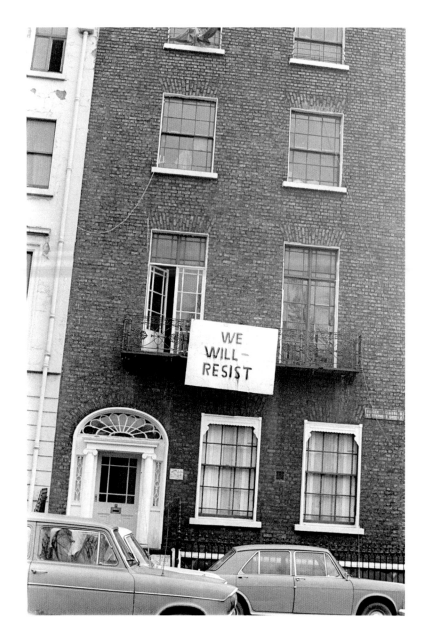

Protest at St. Stephen's Green East.

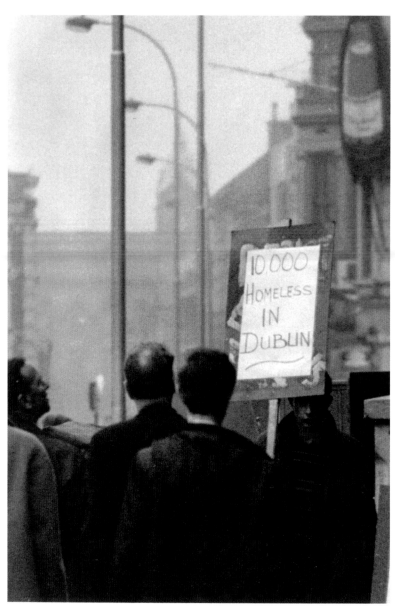

A man carrying a placard protesting about the number of
homeless in Dublin. St. Stephen's Green North.

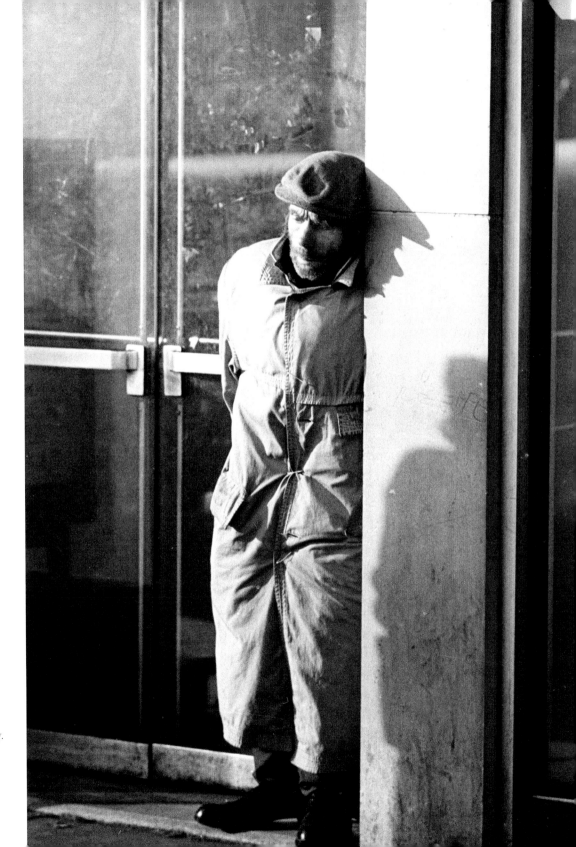

Waiting for time to pass at Liberty Hall on Eden Quay.

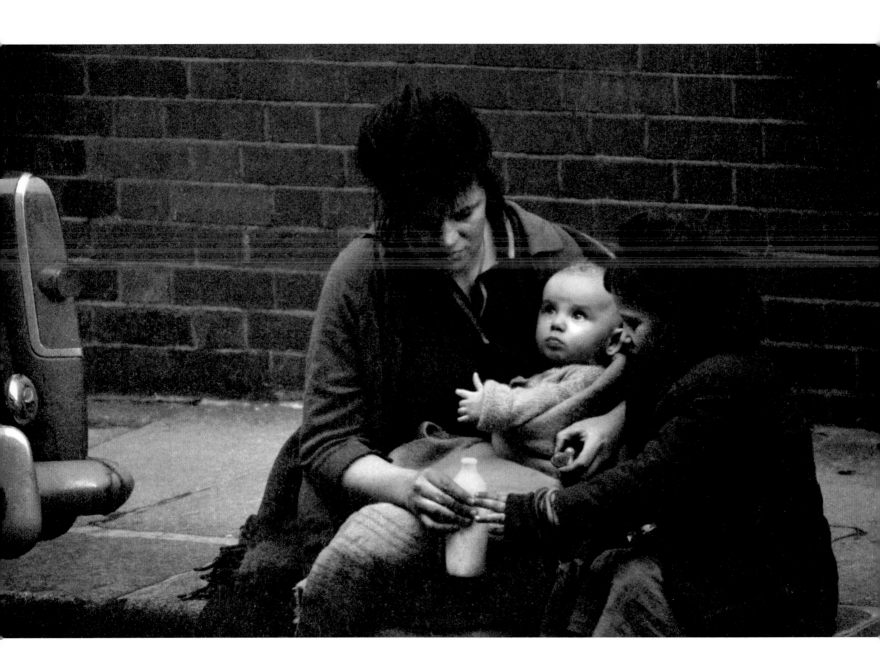

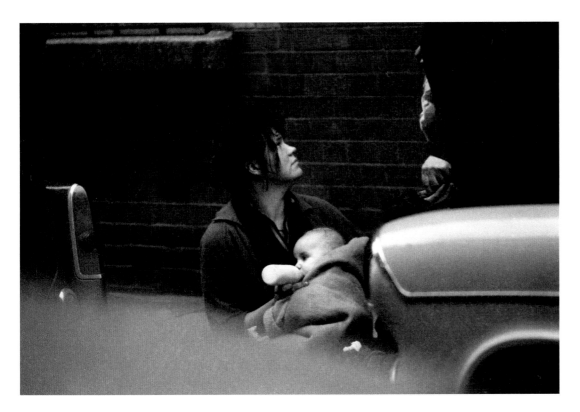

Mother and children from the Travelling community. King Street South.

There is the child the mother cradles without, and the child she cradles within.

The one whose cries chime in her ears, whose innocent beauty twinkles in her eye and whose tiny fingers cling to her with all their might to survive…and the other one, silently felt, tender and pure, still, beneath the layers of the years.

Alyson McEvoy

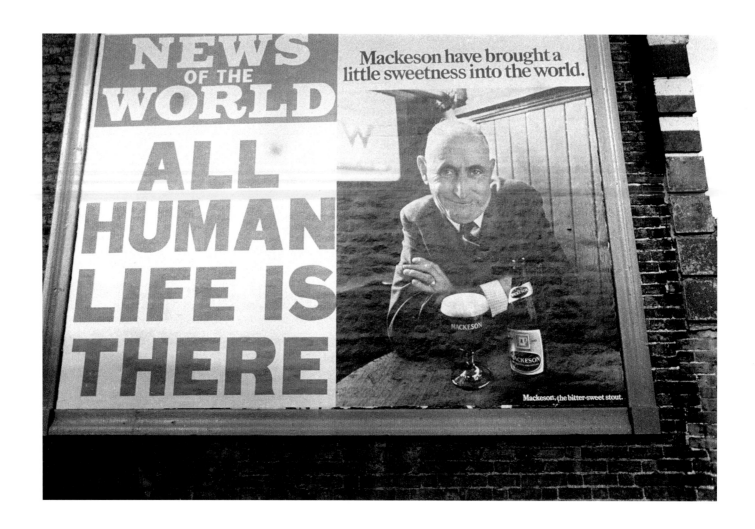

Advertisement poster on Parnell Street.

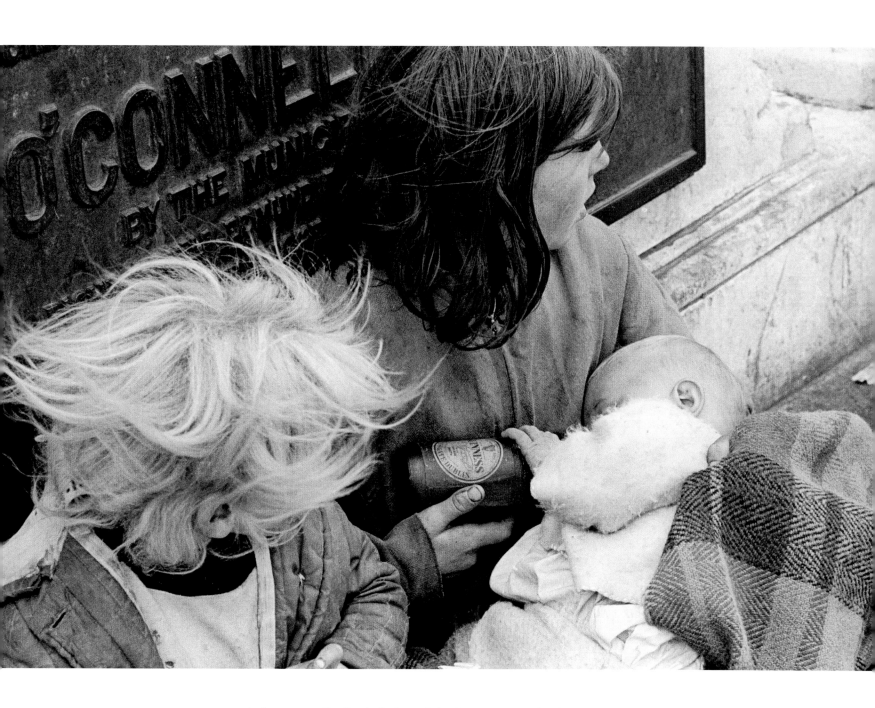

Two young girls from a Traveller family feeding a baby from a Guinness bottle. O'Connell Bridge.

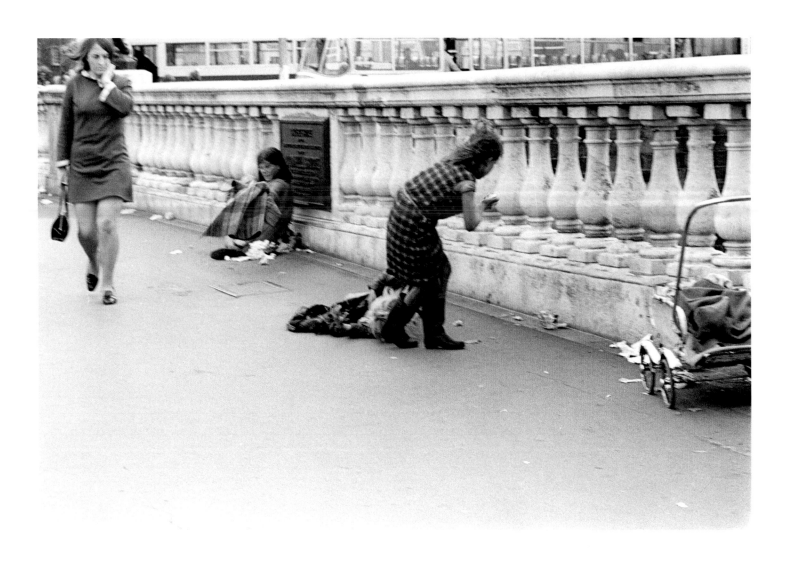

TOP: Travellers begging on O'Connell Bridge.

OPPOSITE: Children love to have their photo taken. Dublin Corporation flats complex.

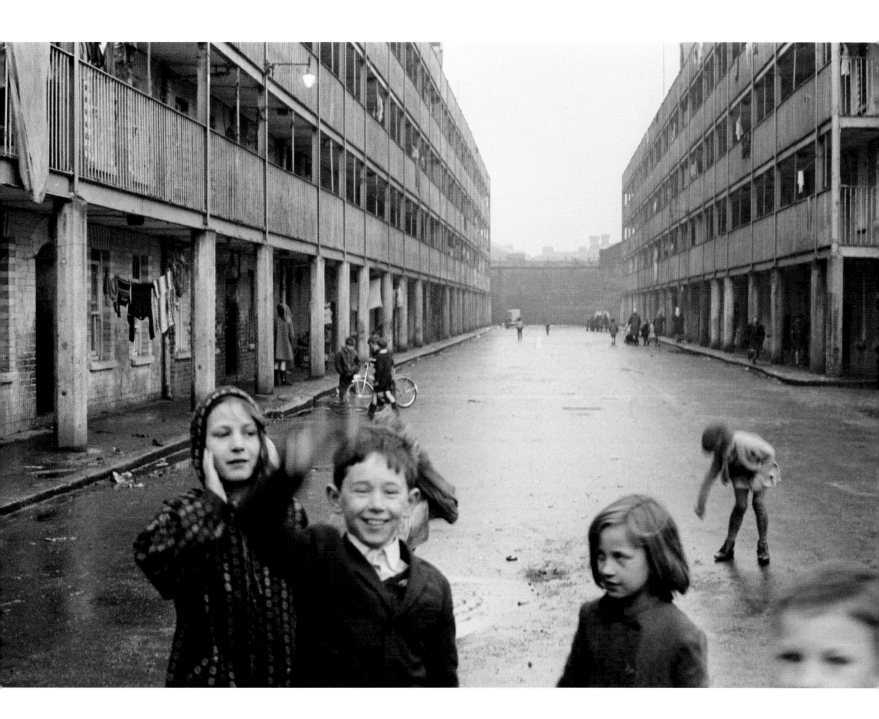

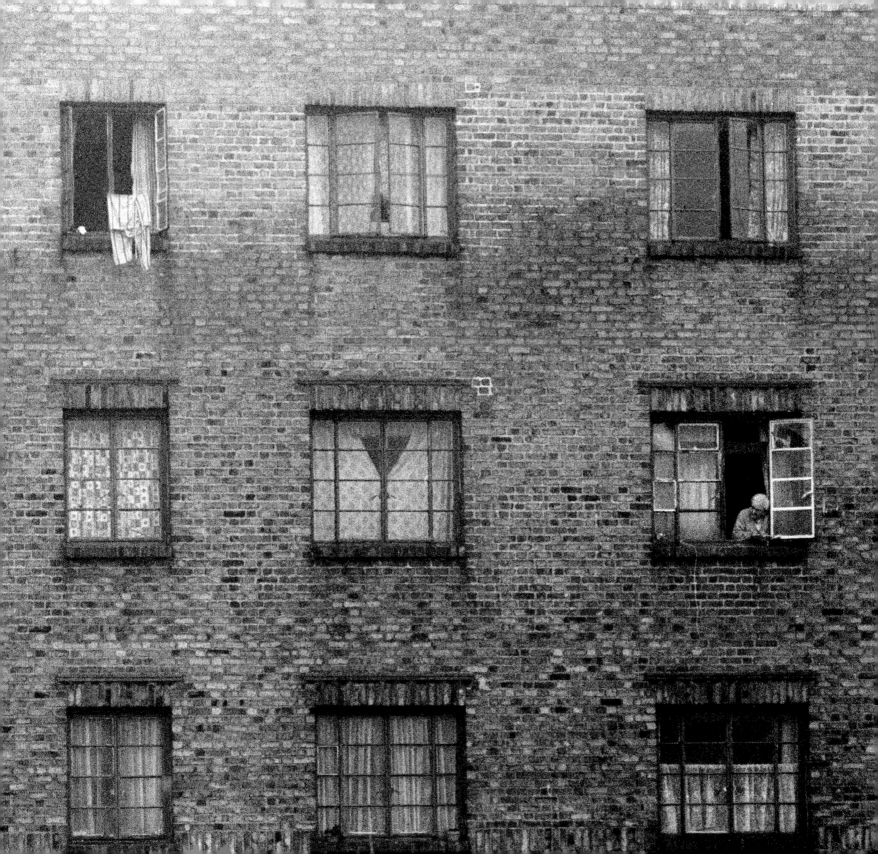

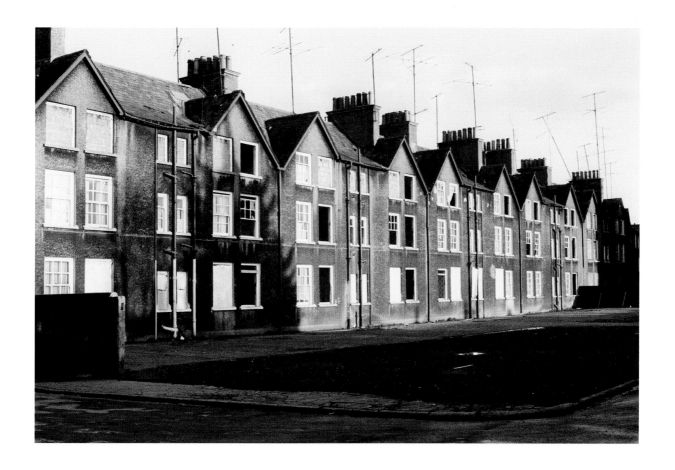

LEFT: An old lady looks out of her window. Foley Street.

TOP: Mount Pleasant Buildings, Ranelagh.

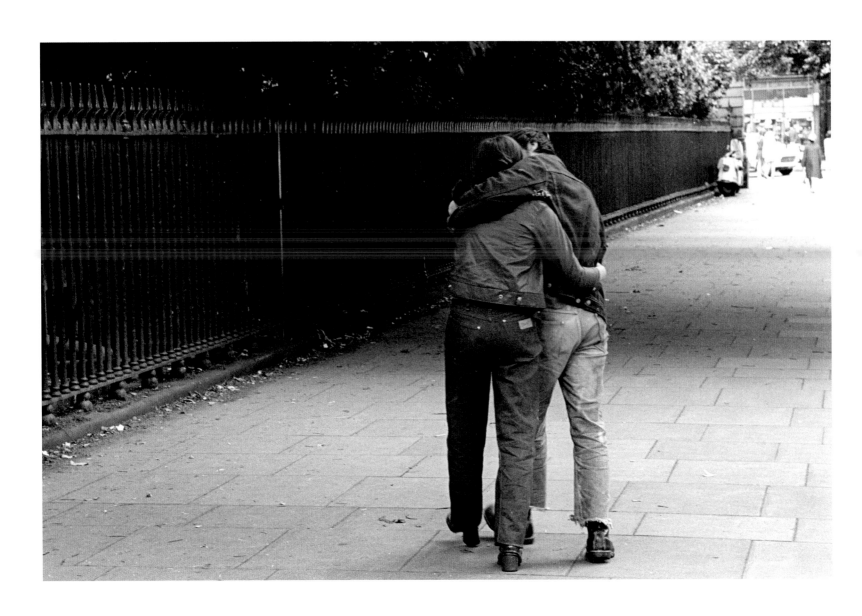

Wrapped up along St. Stephens Green, North.

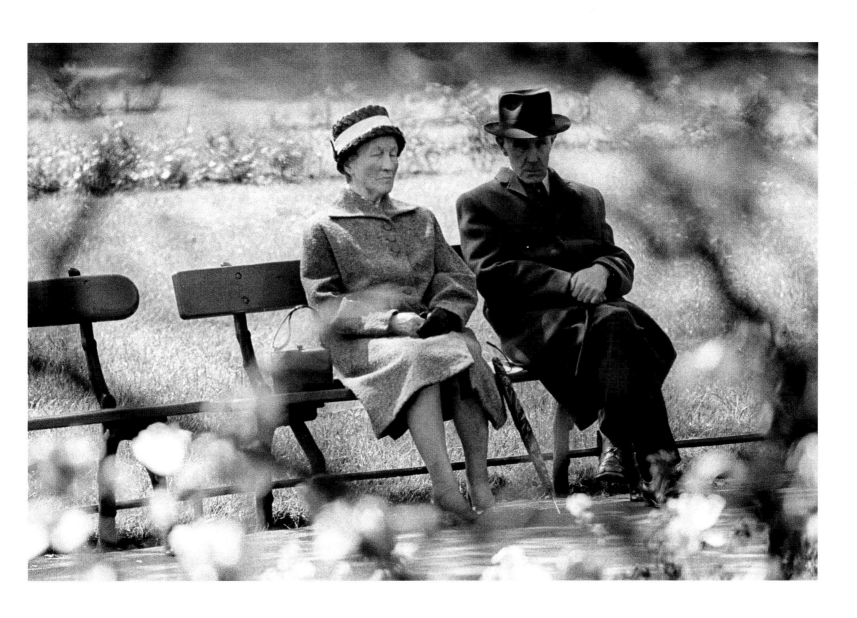

Couple in St. Stephen's Green.

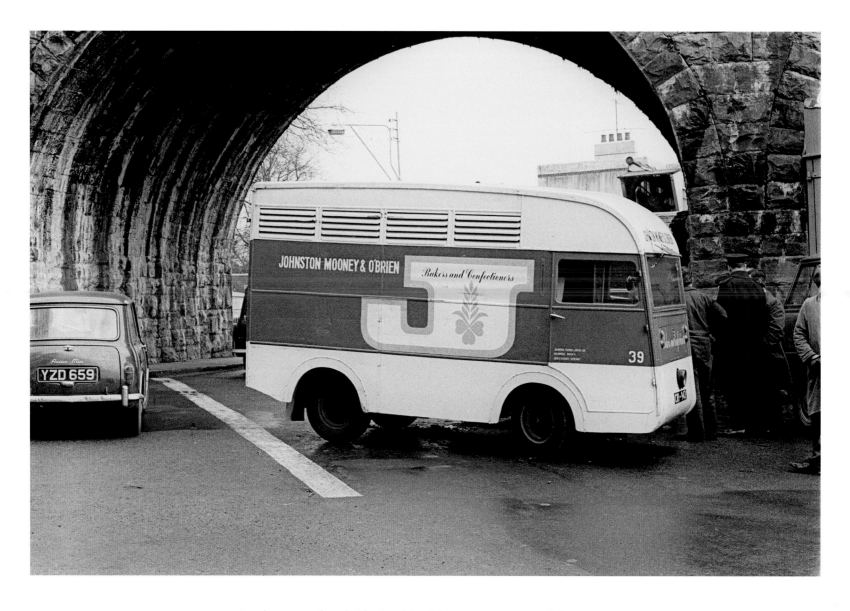

Incident at a railway bridge involving Johnston, Mooney and O'Brien van.

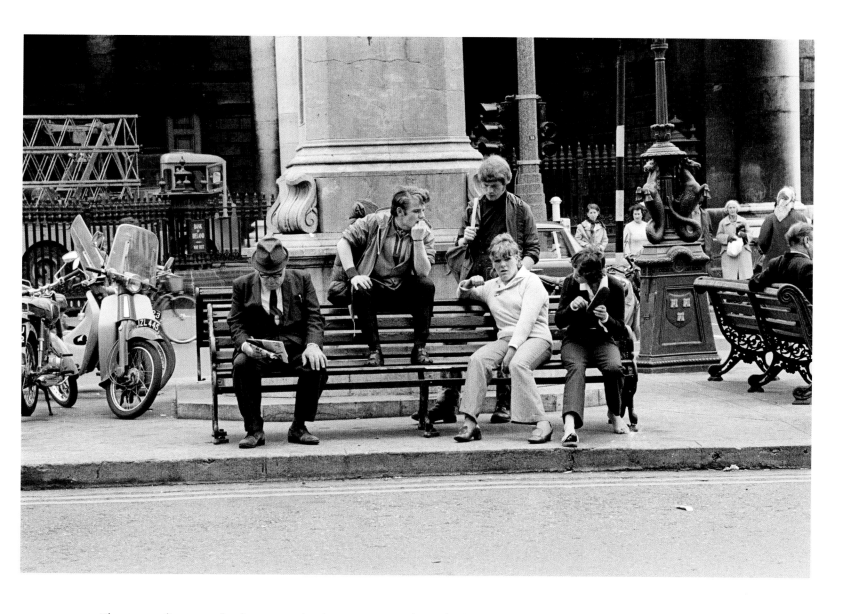

The man reading seemed to be engrossed in his newspaper and completely oblivious of the younger generation. College Green.

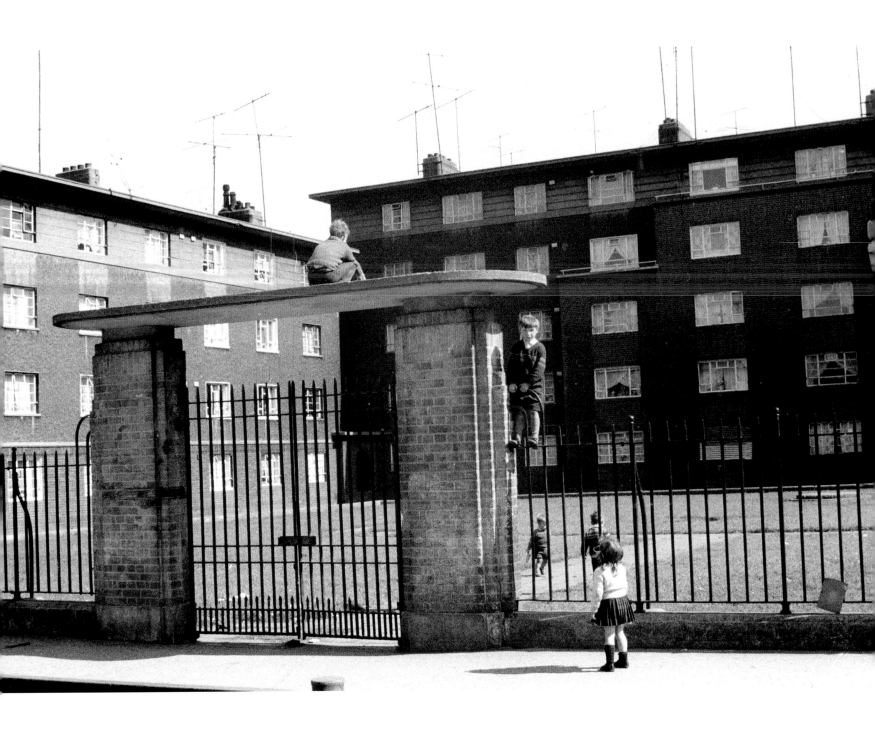

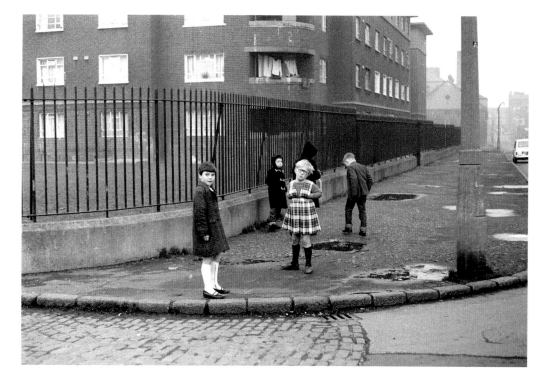

OPPOSITE: Children climbing the perimeter railings and pillars of this flat complex. Off Railway Street.

TOP RIGHT: Corner of James Joyce Street and Railway Street.

BOTTOM RIGHT: Boys relaxing on Poplar Pow.

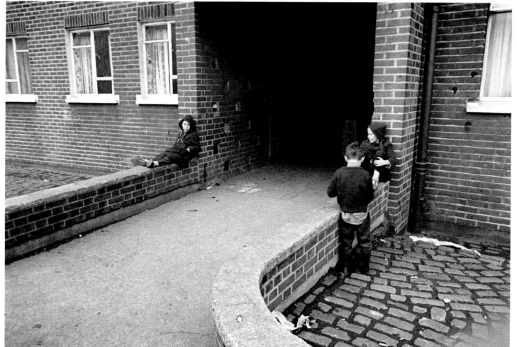

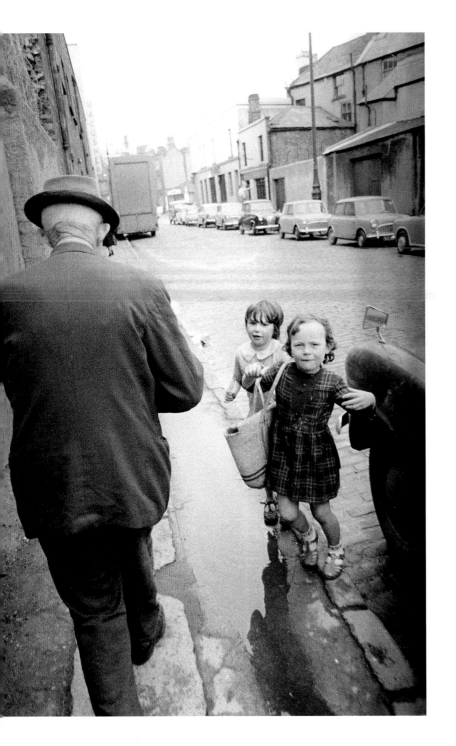

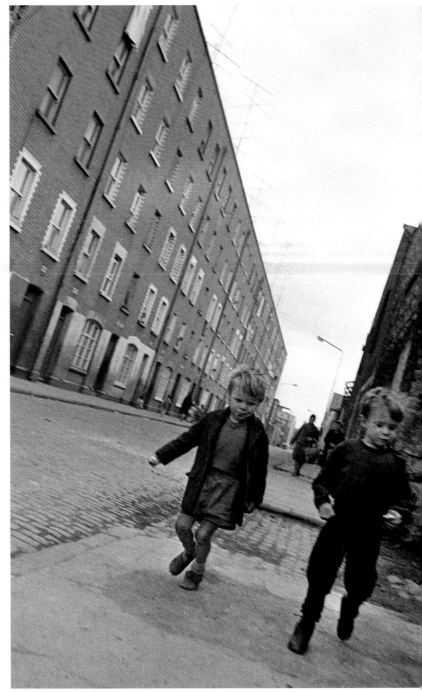

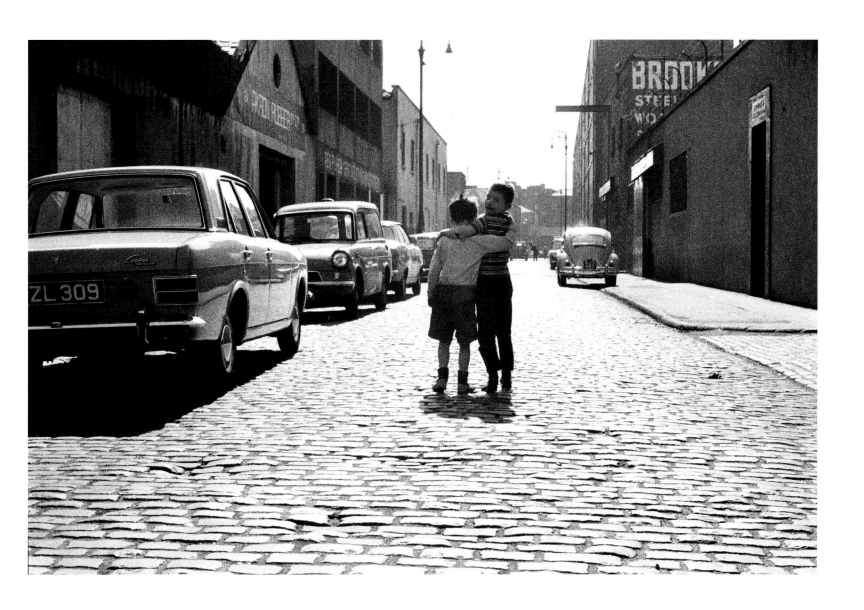

OPPOSITE LEFT: Near the Macushla Ballroom on Amiens Street.

OPPOSITE RIGHT: Tripping lightly along the way. Buckingham Street.

TOP: Two young pals make their way by Brooks Steel Works, Foley Street.

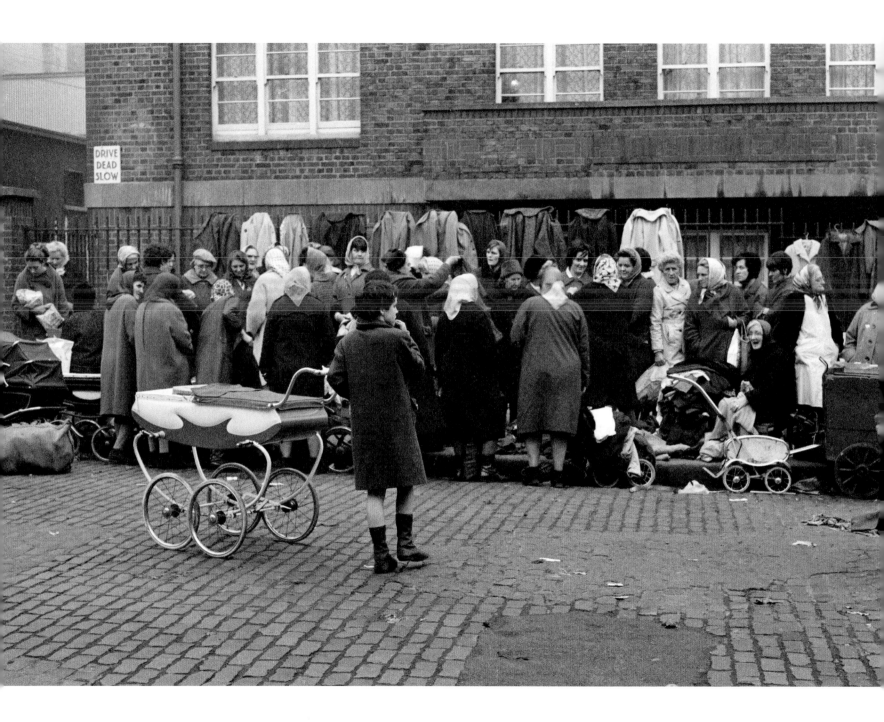

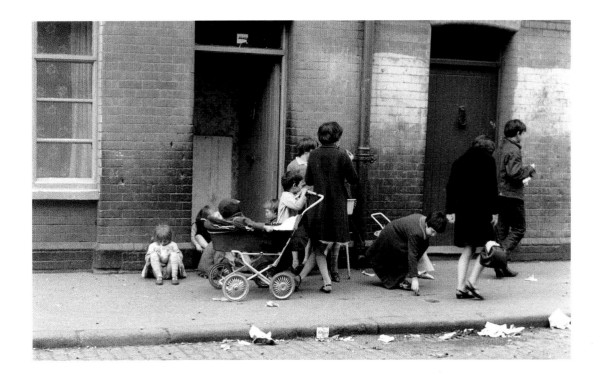

OPPOSITE: Secondhand clothes market on Cumberland Street North.

TOP RIGHT: Meeting place, Portland Row area.

BOTTOM RIGHT: Parnell Street / Summerhill area.

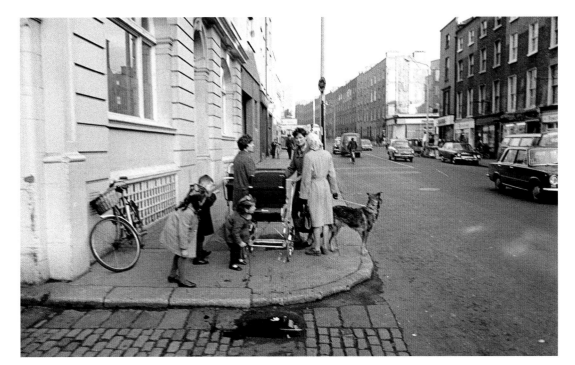

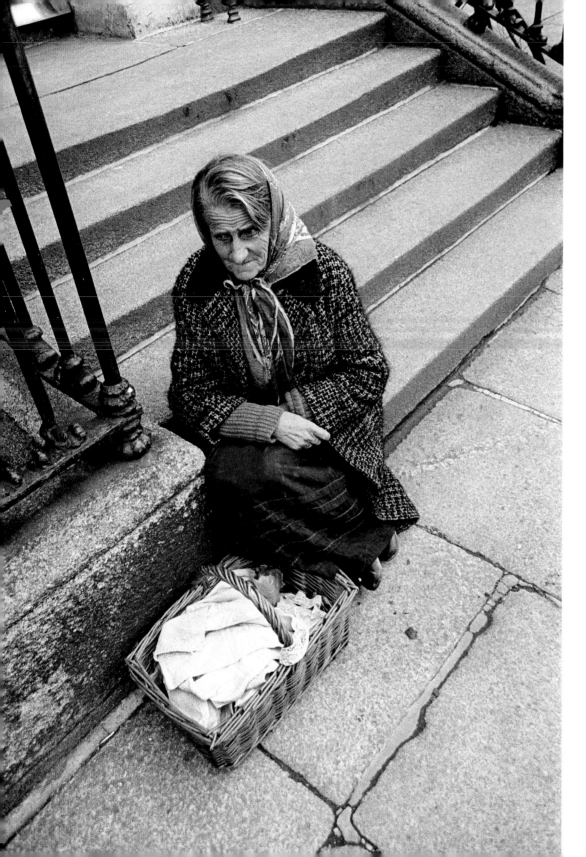

Old woman resting on a door step with her basket.
Gardener Street.

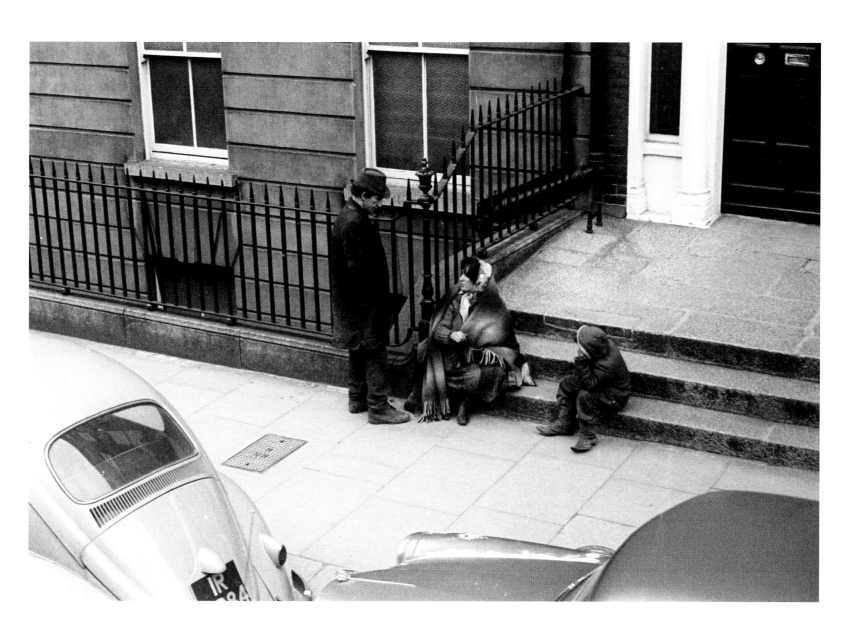

Traveller woman receiving instructions. Gardener Street area.

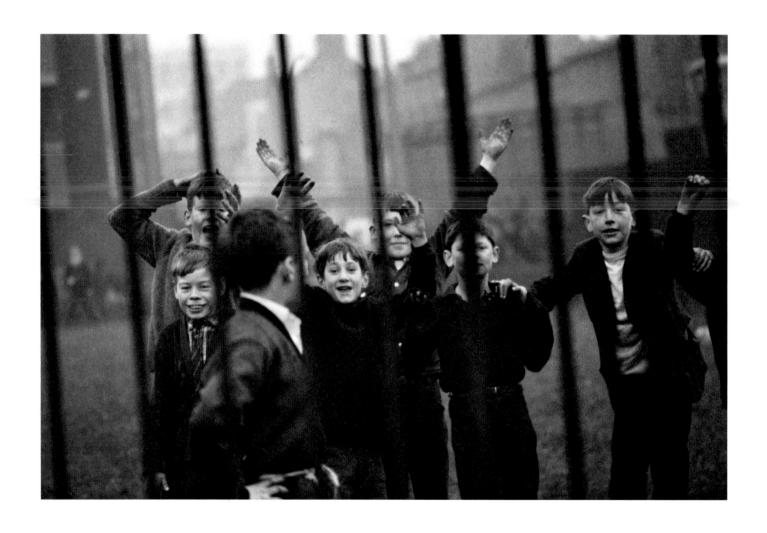

TOP: Boys behind bars at Dublin Corporation flats complex, inner city.

RIGHT: This vacant site on the corner of Buckingham Street Upper and Empress Place was a playground for these children.

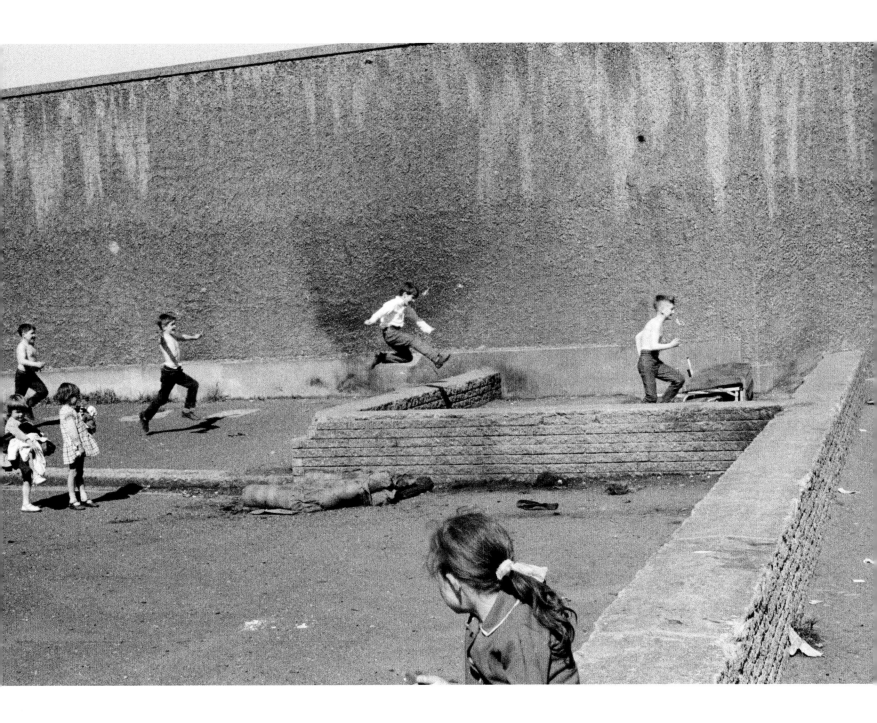

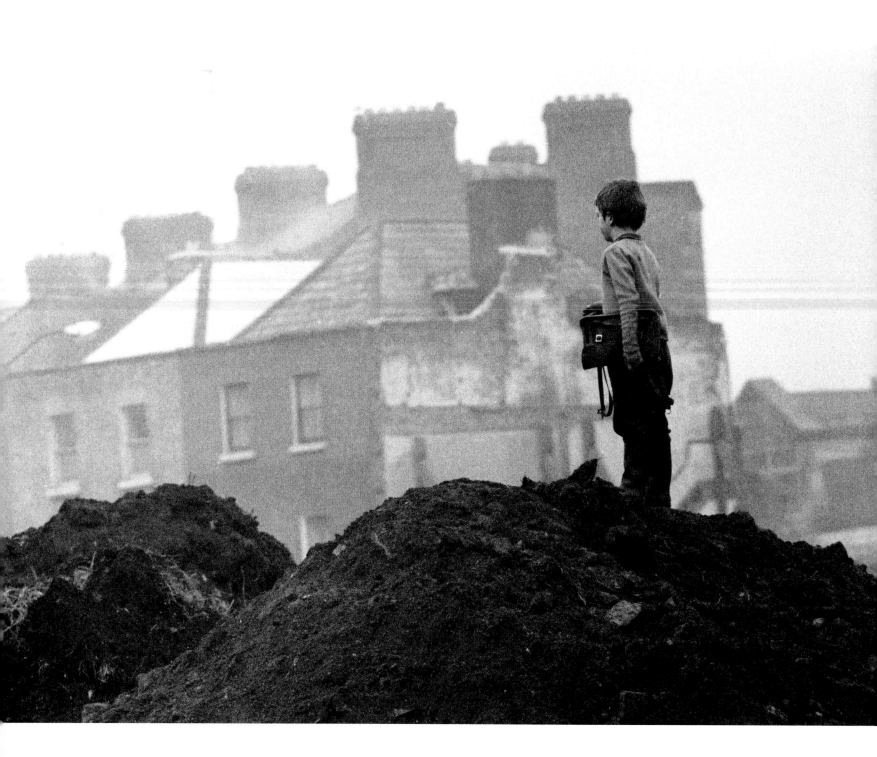

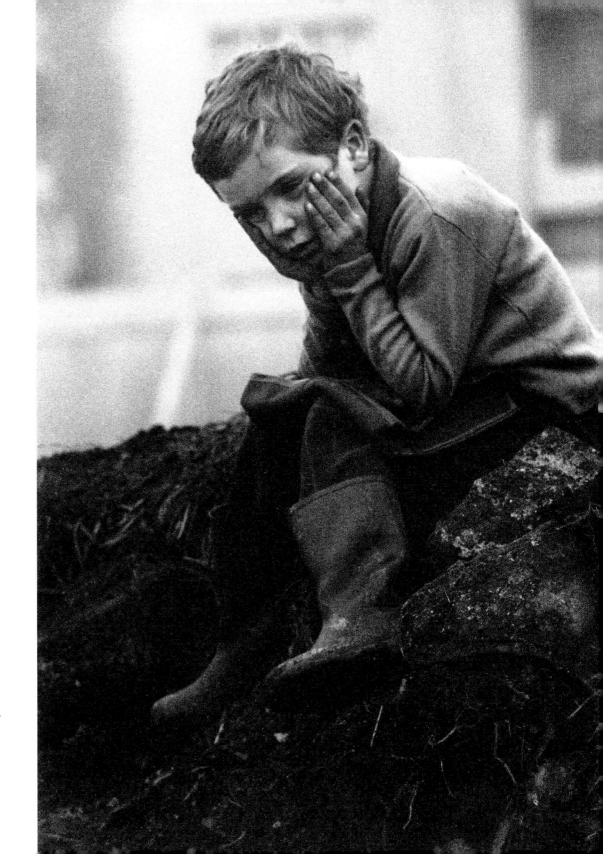

OPPOSITE LEFT: Derelict site on Summerhill.

RIGHT: Boy sitting on a pile of clay at derelict site, Summerhill.

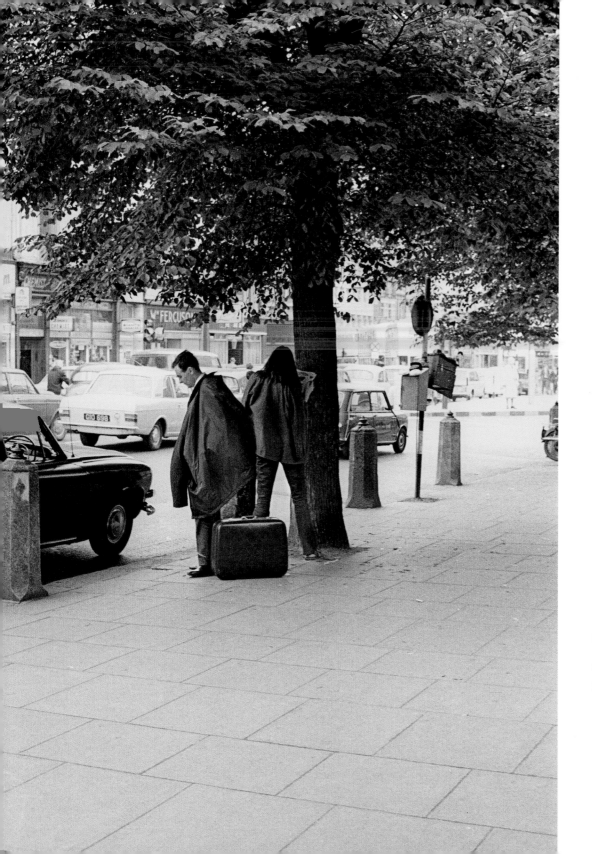

LEFT: Waiting for a taxi at St. Stephen's Green West.

OPPOSITE RIGHT: Chatting up the girls on Lower Abbey Street.

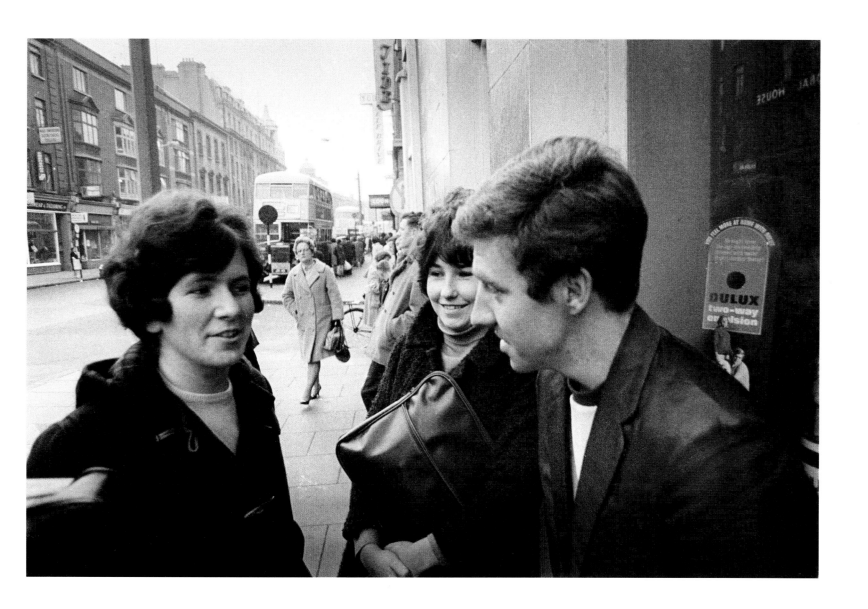

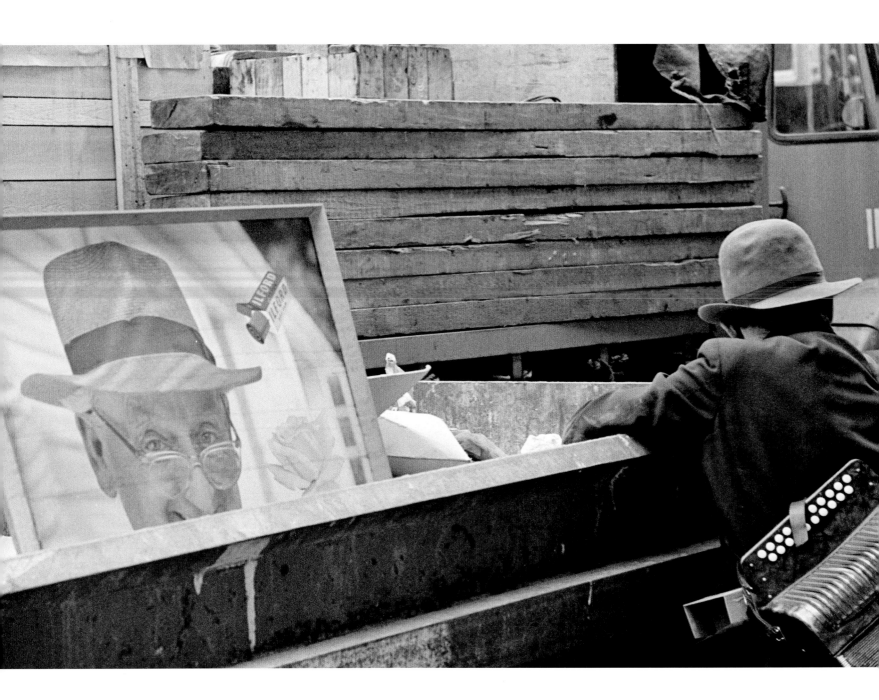

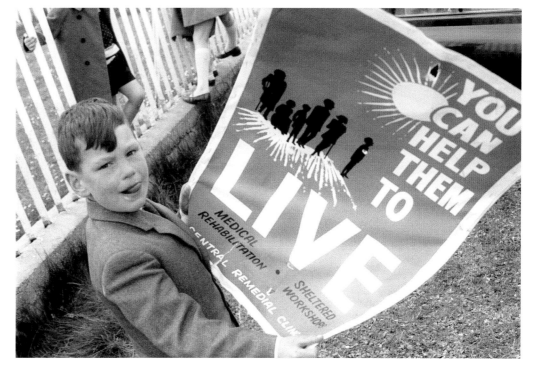

OPPOSITE: Man looking in a builder's skip for anything that might be useful. Grafton Street.

TOP RIGHT: Poster on Summerhill.

BOTTOM RIGHT: A boy holding a Central Remedial Clinic poster.

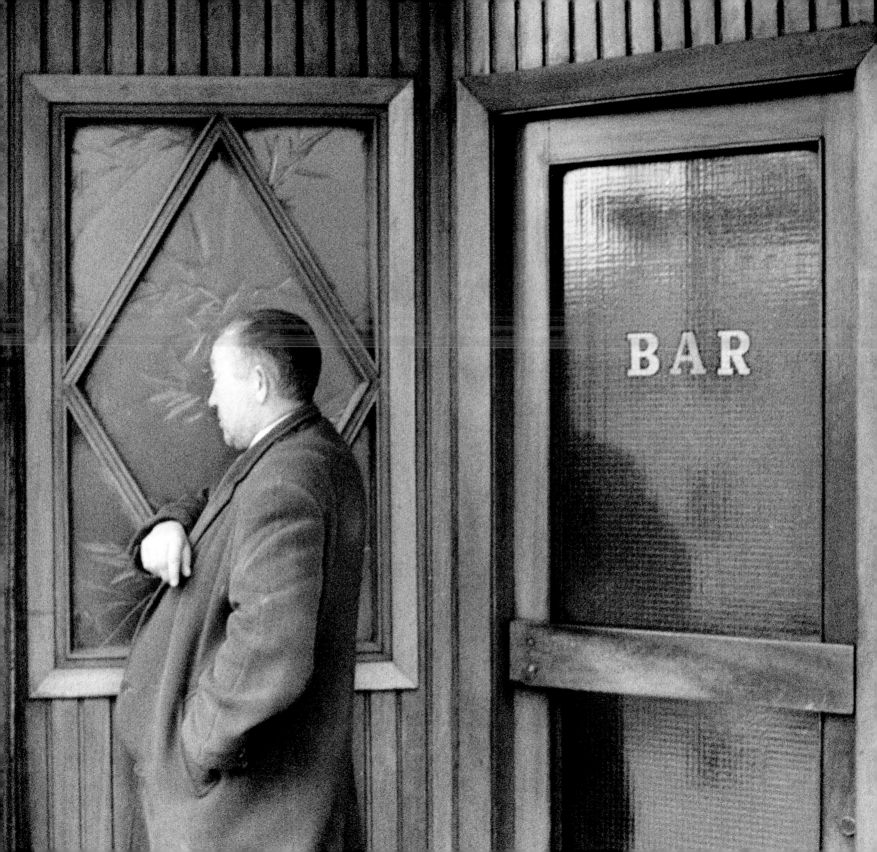

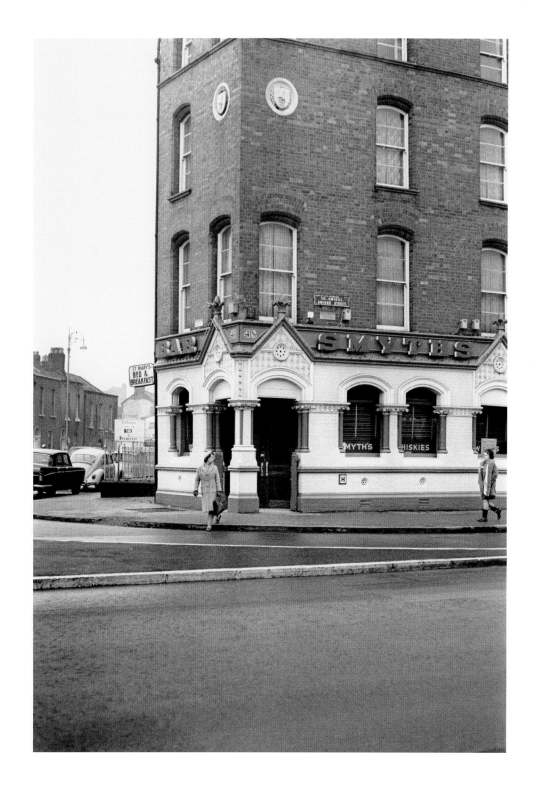

OPPOSITE: Leaving the bar. Lower Abbey Street.

RIGHT: Smyths Bar on Amiens Street.

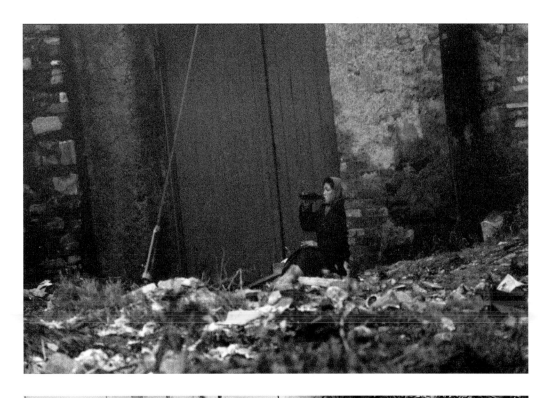

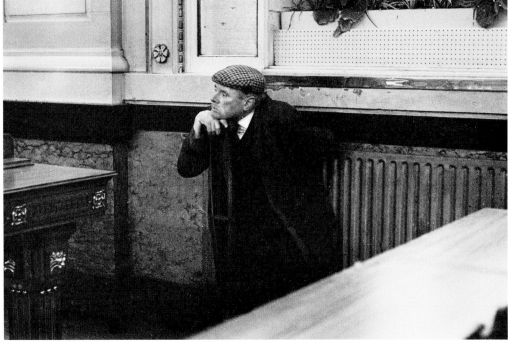

TOP LEFT: A woman drinks from a bottle on derelict site. Off Summerhill.

BOTTOM LEFT: A man, deep in thought, resting on his crutch.

OPPOSITE: Girl with a white ribbon. St. Stephen's Green.

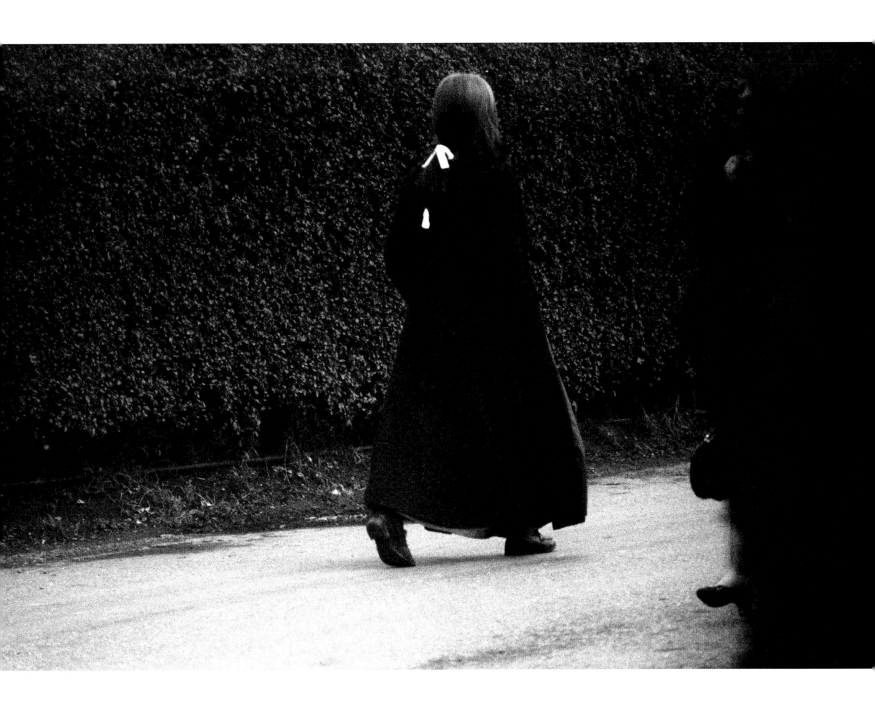

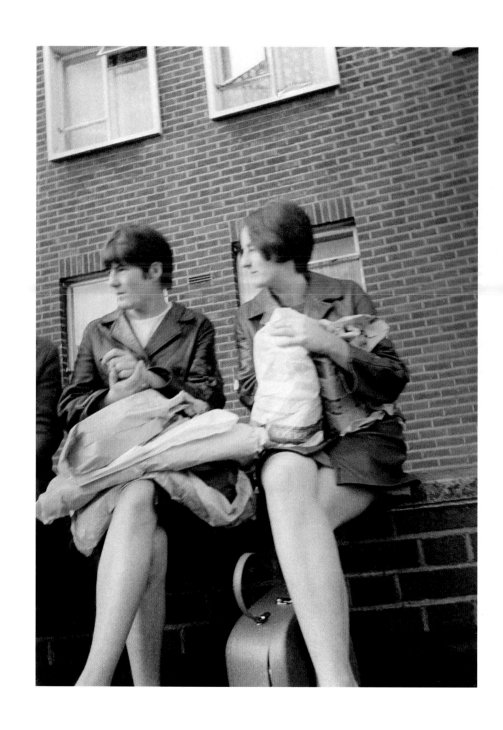

RIGHT: Factory girls taking a break

OPPOSITE: Waiting for the film to start. Regent Cinema.

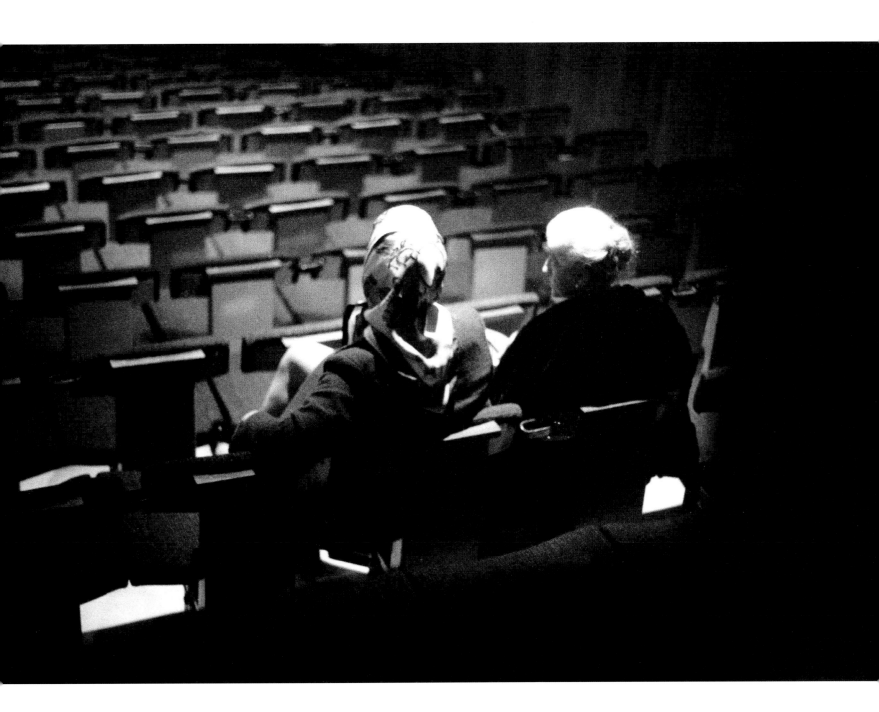

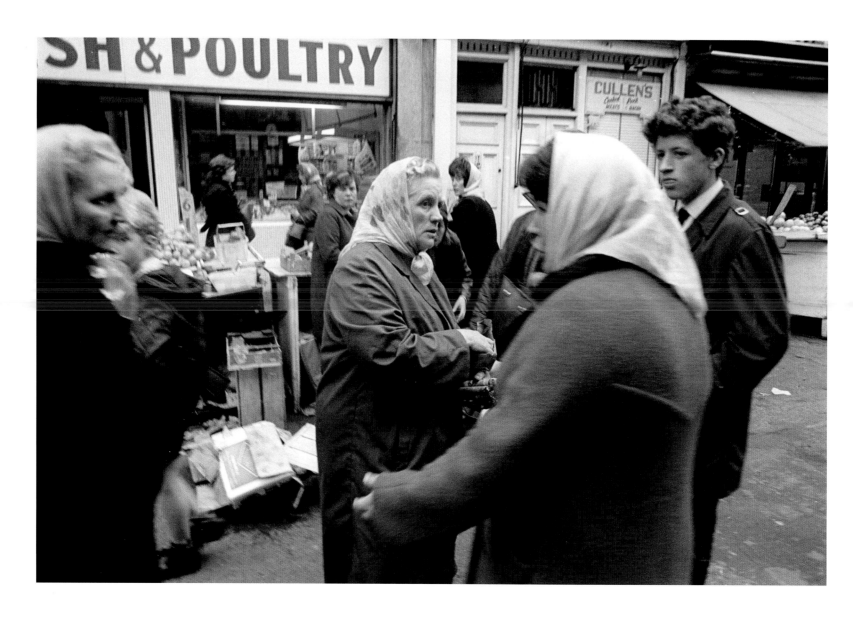

Selling fireworks on Moore Street.

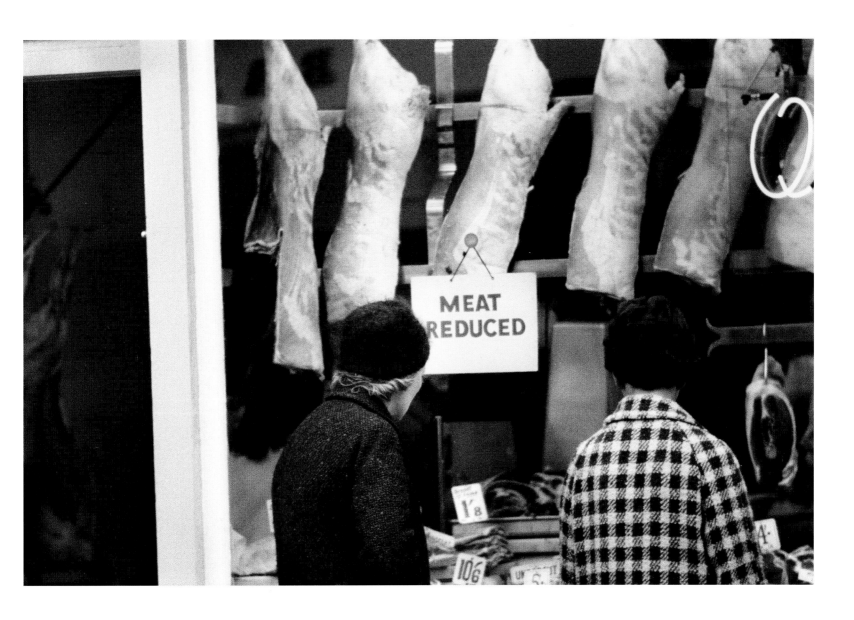

Meat reduced in butchers shop on Talbot Street.

TOP: Lady with the mystic smile. Secondhand shop on Capel Street.

RIGHT: This shop sold all sorts of secondhand furniture along with vintage cars. Capel Street.

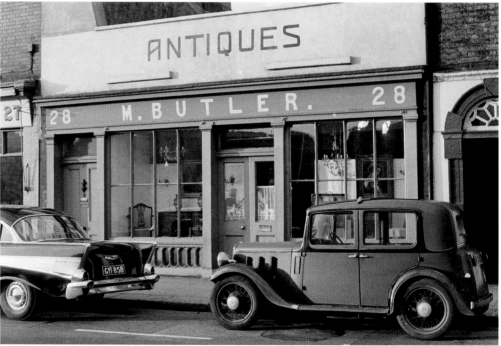

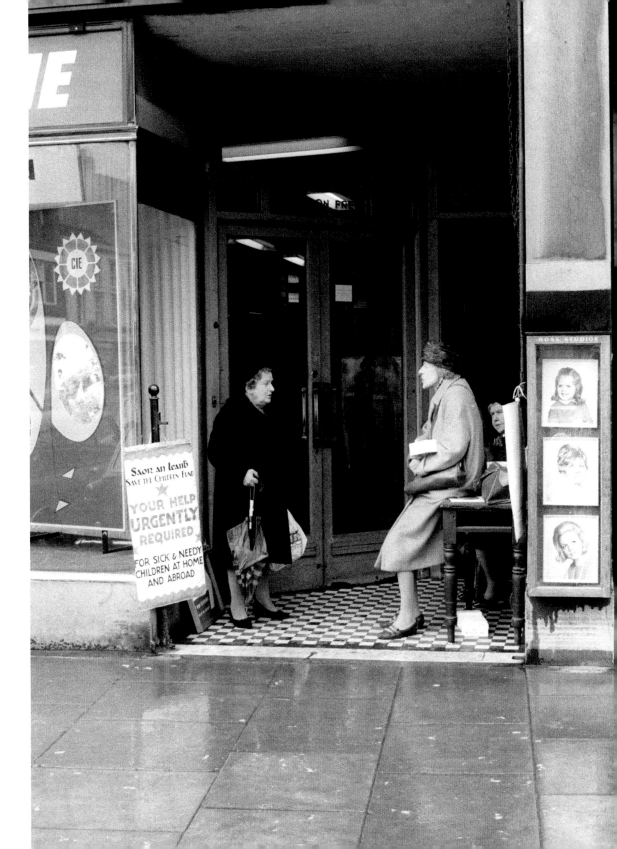

Friends stop for a chat outside the Dublin Bus
Office, O'Connell Street.

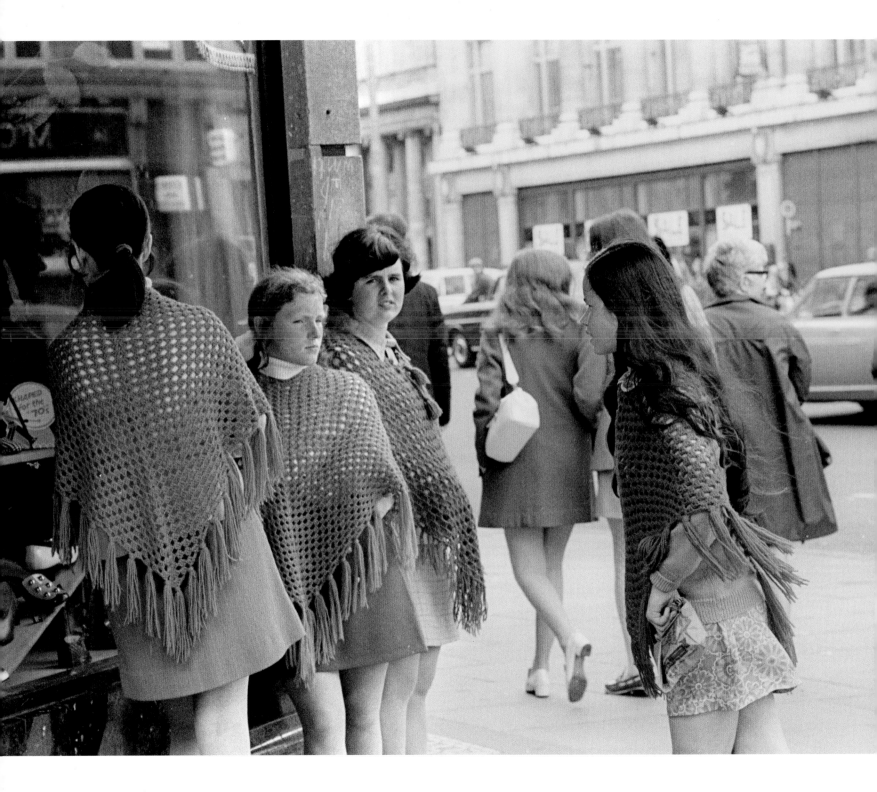

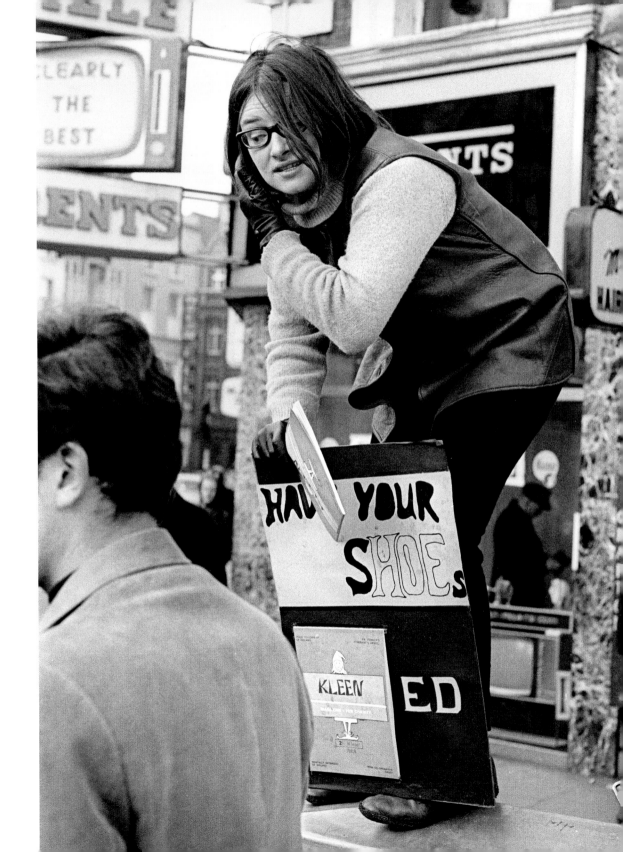

OPPOSITE: School girls on the corner of Middle Abbey Street and O'Connell Street.

RIGHT: Time to have your shoes cleaned. Street corner, Henry Street area.

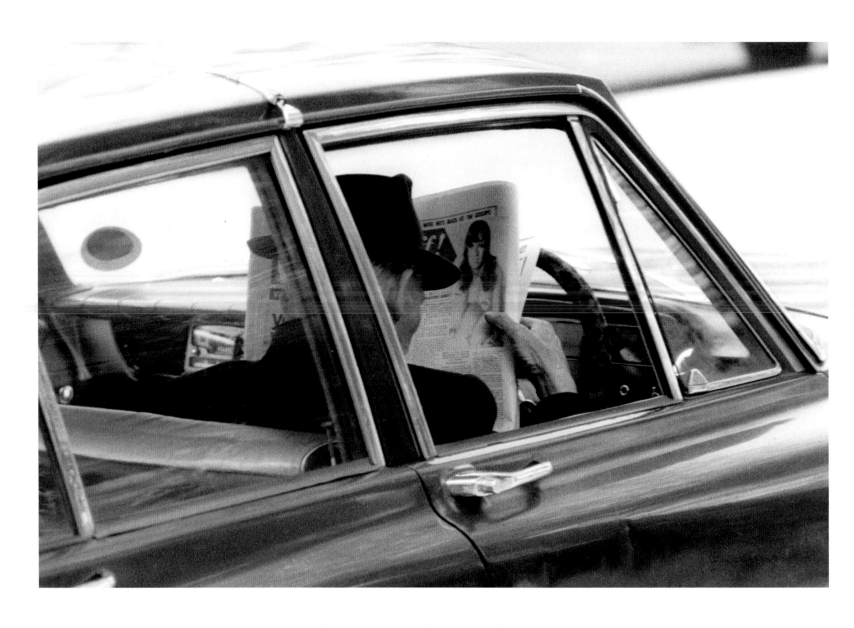

Man reading a newspaper in his car. St. Stephen's Green East.

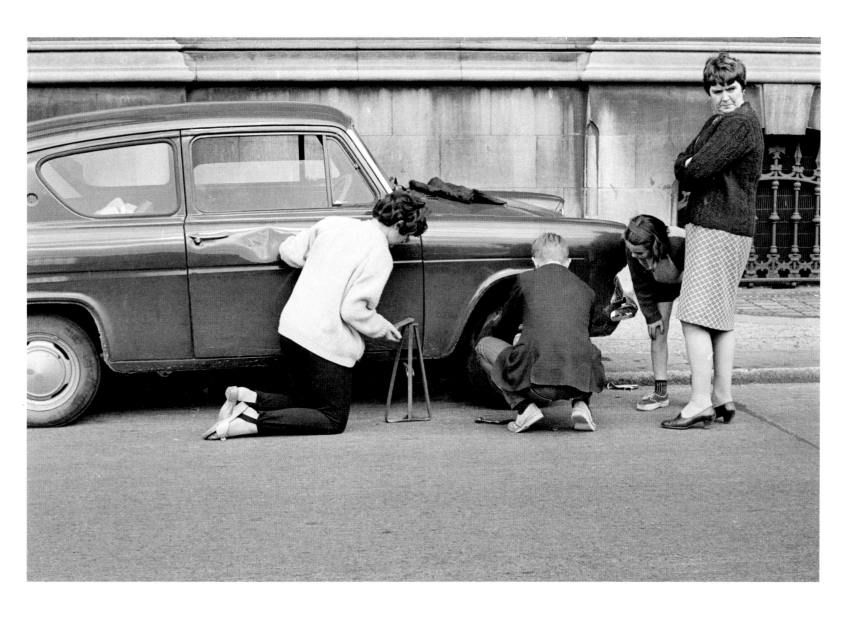

Attempting to change a wheel on Dorset Street.

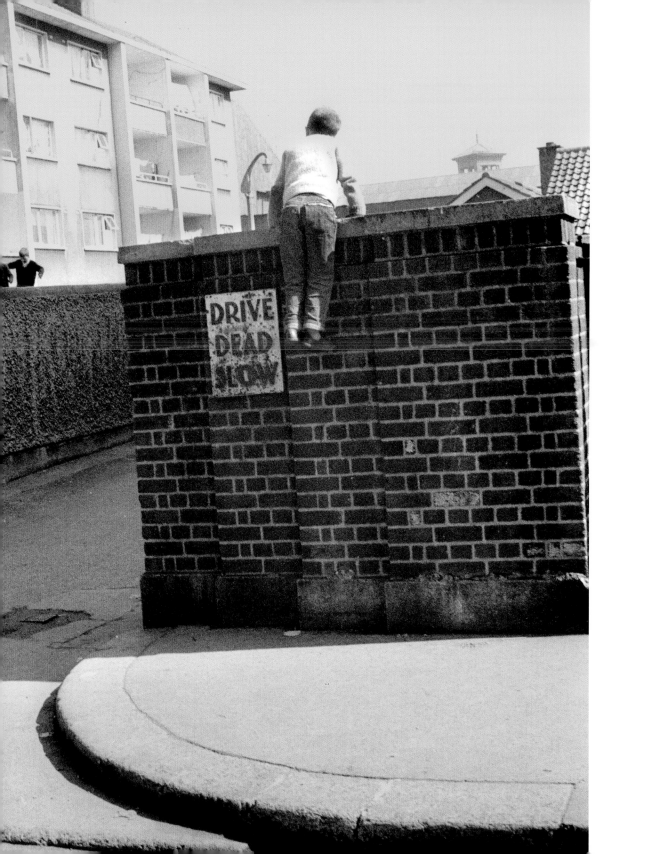

OPPOSITE: Scaling the heights at Corporation flats complex.

TOP: A sunny day in St. Stephen's Green.

BOTTOM: Young Traveller girl begging on O'Connell Bridge.

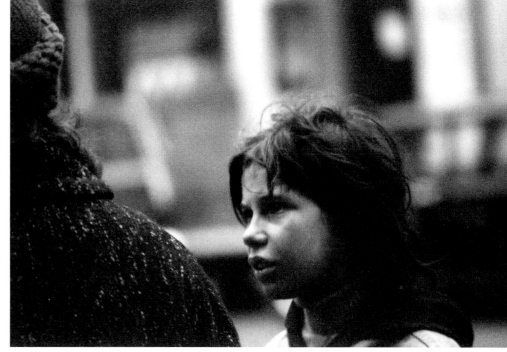

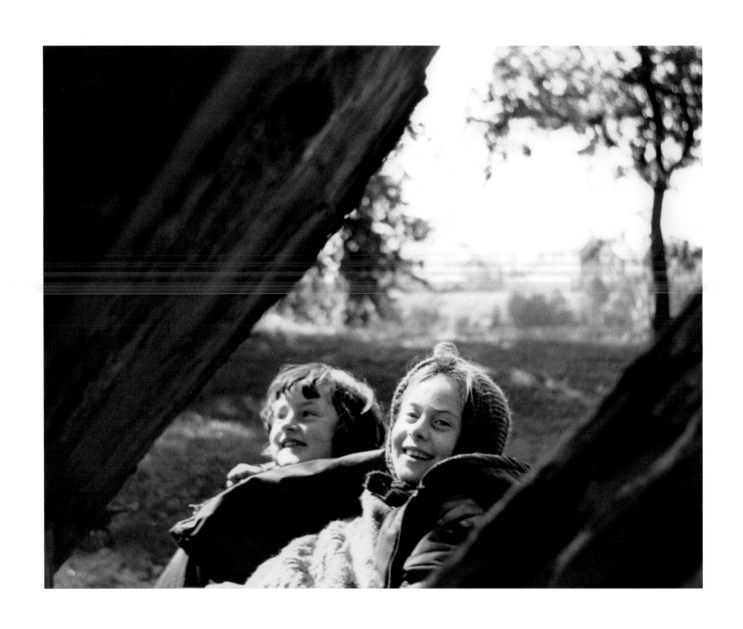

TOP: Girls laughing through a split in a tree, Orwell Park, Churchtown.

OPPOSITE RIGHT: Posing for a photograph. St. Stephen's Green.

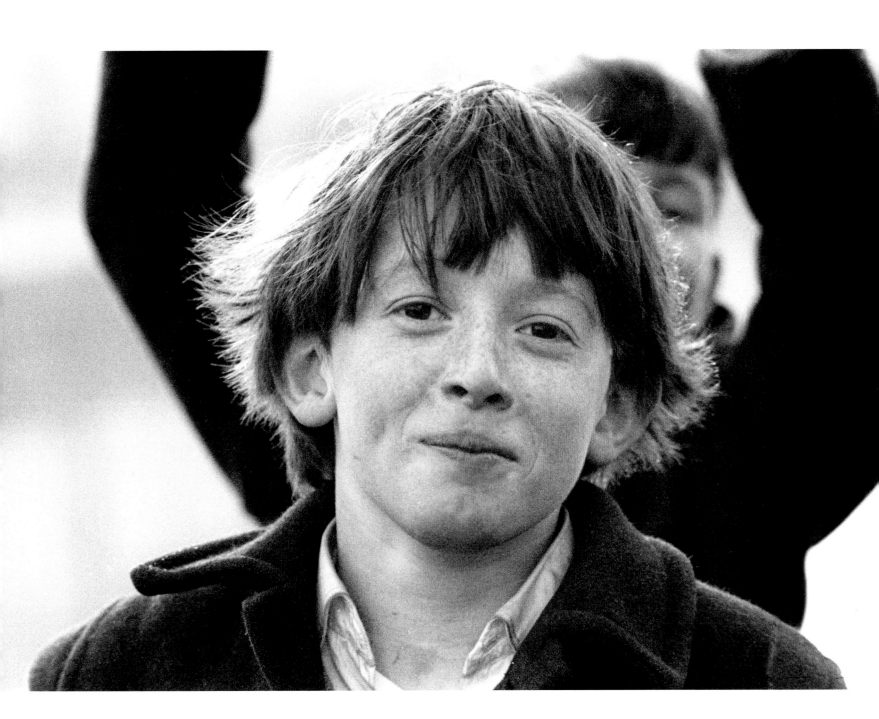

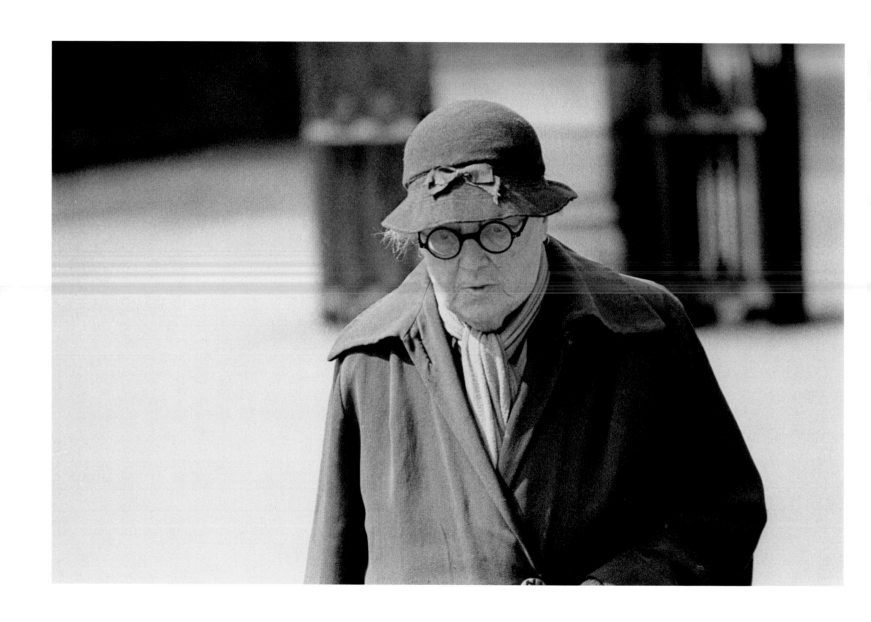

TOP: A woman goes about her business on O'Connell Street.

OPPOSITE: A curly haired child holding her mother's hand.

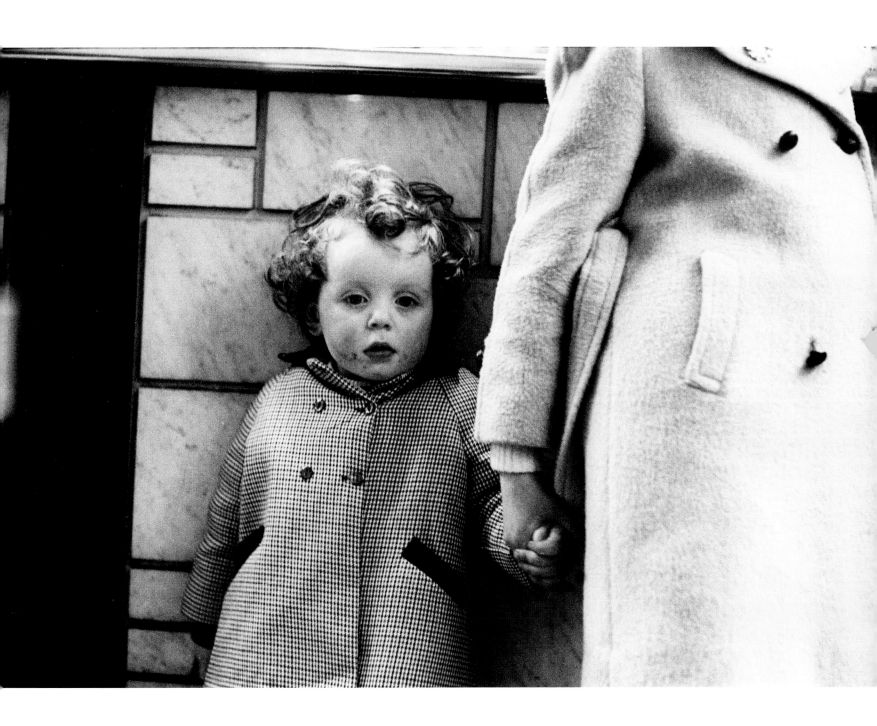

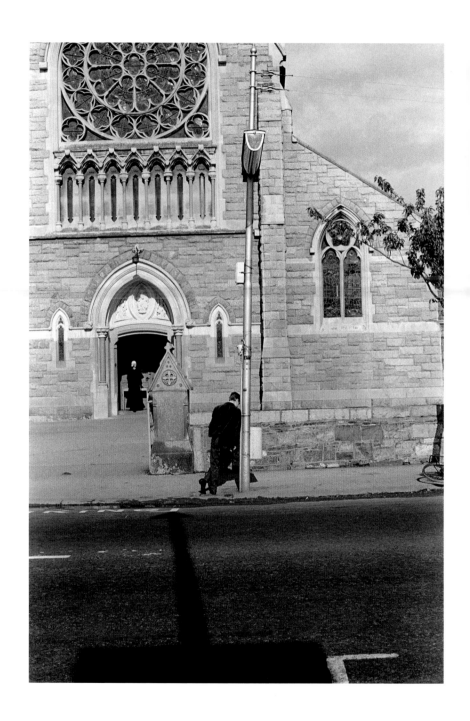

RIGHT: Won't you come in? Church of the Sacred Heart, Donnybrook.

OPPOSITE: The Legion of Mary at work by the Bank of Ireland, College Green.

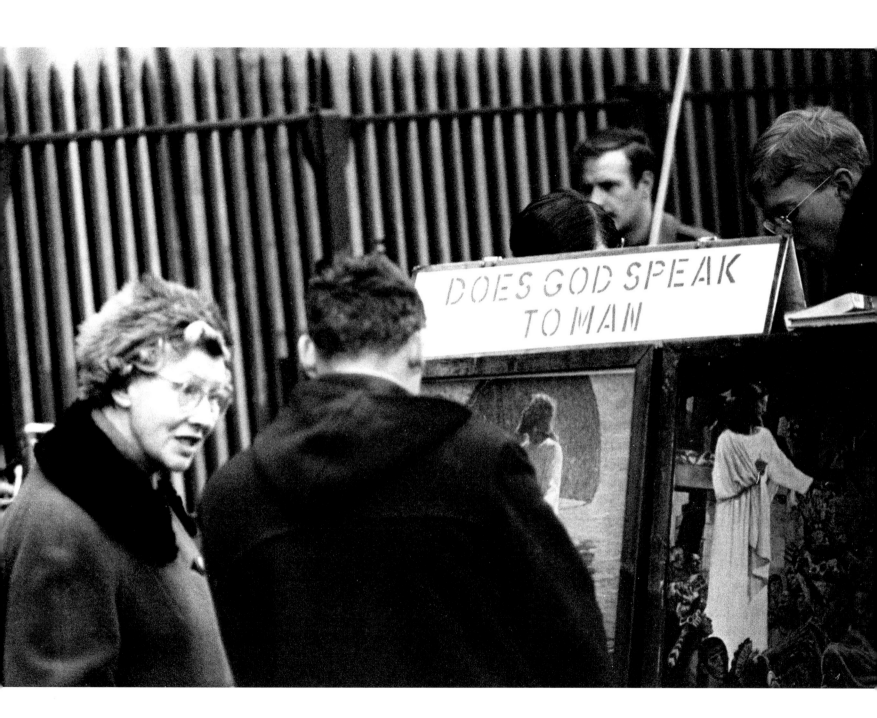

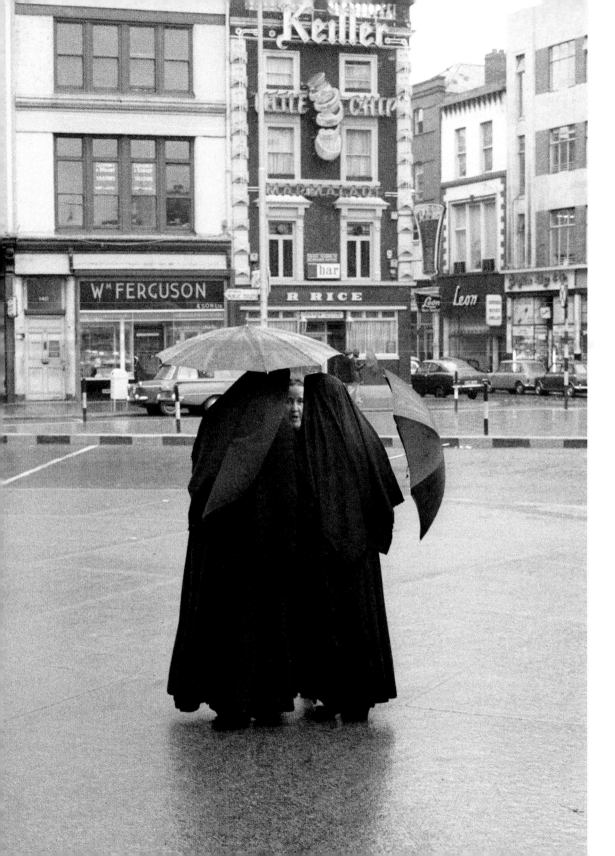

The buildings in the background of this photograph were demolished during the 1980's to make way for the Stephen's Green Shopping Centre at the top of Grafton Street.

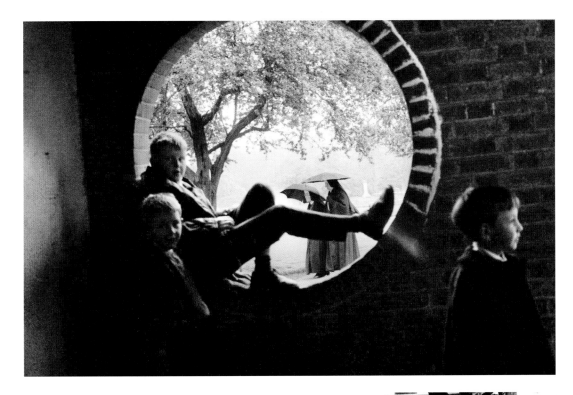

TOP: These boys were more interested in the camera than anything else at that moment. St. Stephen's Green.

RIGHT: Man with an umbrella in St Stephen's Green.

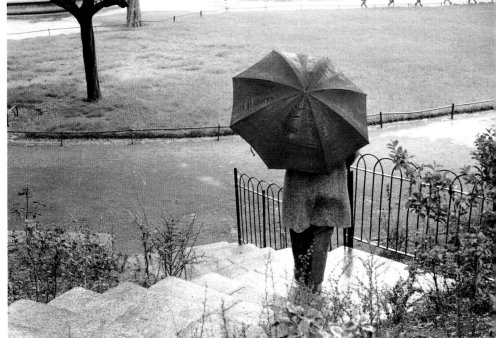

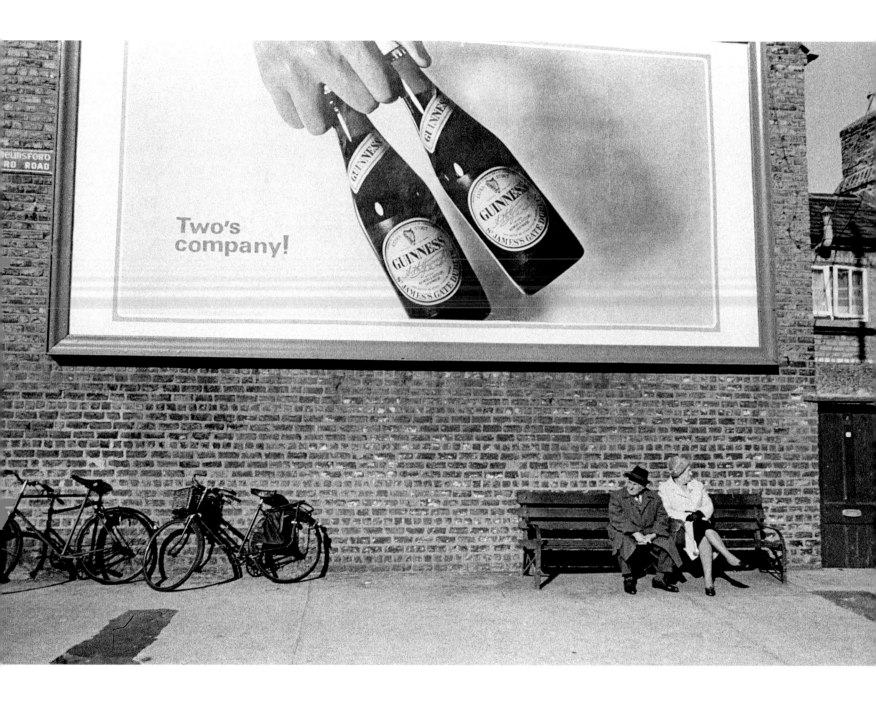

Two's company on Chelmsford Road in Ranelagh.

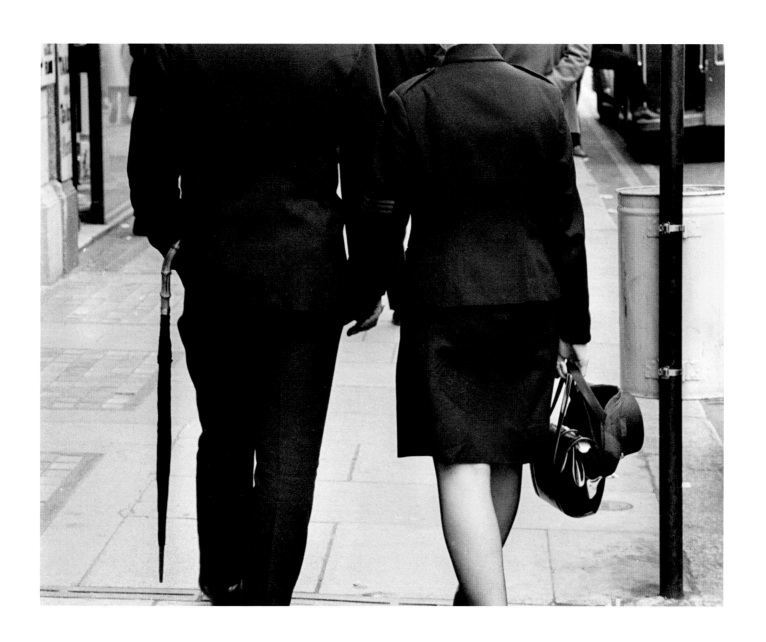

A Salvation Army couple in Westmoreland Street.

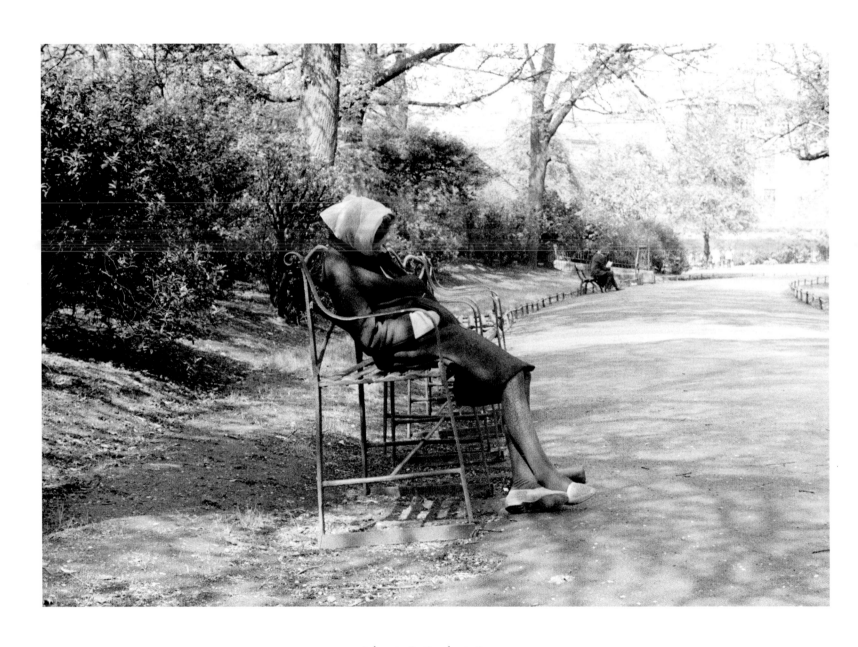

Asleep in St. Stephen's Green.

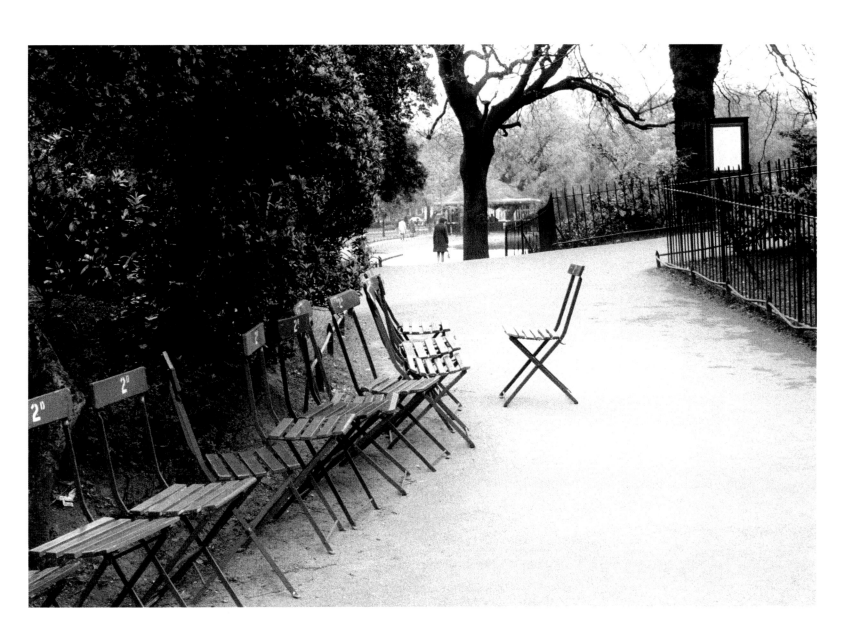

There was a charge of 2 pence for use of a seat in St. Stephen's Green.

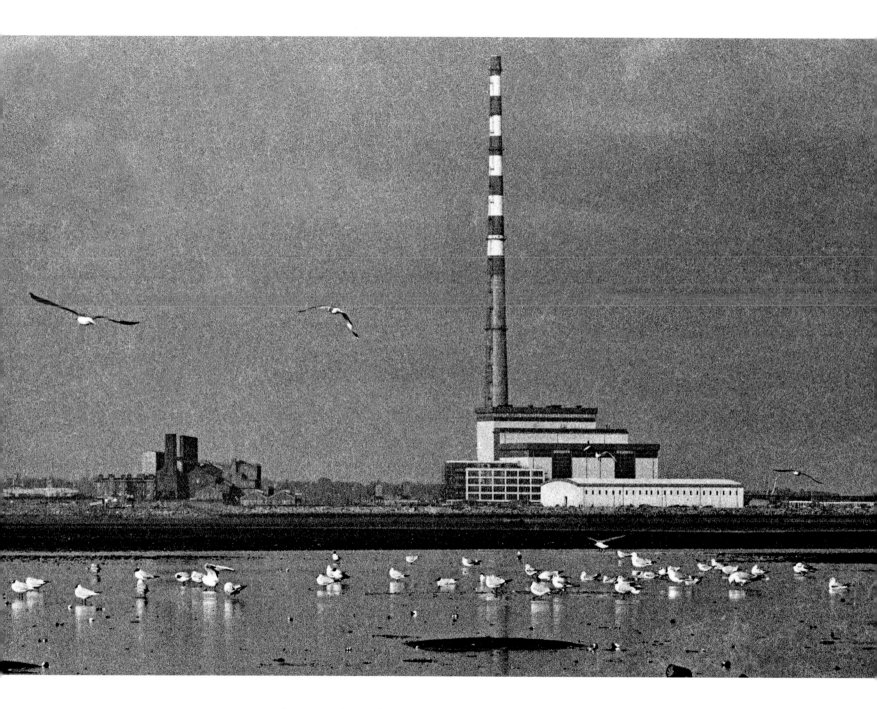

There was only one chimney at this time at Poolbeg Generating Station.

ACKNOWLEDGEMENTS

I would like the thank Elizabeth Kirwan of the National Photographic Archive. She was the first to see my collection of photographs and expressed the view that they should be published in book form. This gave me the motivation to do something about it.

I would also like to thank Jim Butler of Inspirational Arts who did a wonderful job of cleaning up my sadly neglected negatives.

My sincerest thanks to Mags Gargan and her team at Currach Books who put shape on the book.

Most of all I want to thank my friend Alyson McEvoy who encouraged me throughout this project from start to finish and provided the text on pages 45 and 49.